a wax workshop
in mixed-media art

DANIELLA WOOLF

the
encaustic
studio

INTERWEAVE.
interweave.com

EDITOR Elaine Lipson

ART DIRECTOR Liz Quan

DESIGNER Pamela Norman Berman

PHOTOGRAPHER Joe Coca

PRODUCTION Katherine Jackson

TECHNICAL EDITOR Laura Tyler

ILLUSTRATOR Ann Sabin Swanson

EDITORIAL ASSISTANT Mary E. KinCannon

VIDEO DIRECTOR Garrett Evans

VIDEO EXECUTIVE PRODUCER Rebecca Campbell

VIDEO CAMERA Carolyn Getches, Rachel Link

VIDEO PACKAGE DESIGN Julia Boyles

Interweave Press LLC
201 East Fourth Street
Loveland, CO 80537
interweave.com

Printed in China by Asia Pacific Offset Ltd.

Library of Congress Cataloging-
in-Publication Data

Woolf, Daniella, 1948-
 The encaustic studio : a wax workshop in mixed-media
art / Daniella Woolf.
 p. cm.
 Includes bibliographical references and index.
 ISBN 978-1-59668-390-7 (pbk. w. DVD : alk. paper)
 1. Encaustic painting--Technique. I. Title.
 ND2480.W67 2012
 751.4'6--dc23
 2011039242

10 9 8 7 6 5 4 3 2 1

acknowledgments

To my parents, Billy and Sally Woolf, who always supported my creativity in every way possible. I know you're smiling down on me.

To Kim Tyler, for being my life partner and brilliant shining light in the universe. I can't begin to thank you for the myriad ways in which you help me do everything with ease, joy, and laughter.

To Wendy Aikin and Judy Stabile, my partners at Wax Works West, for our shared vision. Thank you for always making me laugh, for your talent as artists, your tremendous teaching skills, and for being the best traveling buddies a girl could have. You take everything to the limit with kindness and love.

To Desmond, for all the bursts of love you regularly pour into my heart.

To Lynda Watson and Jane Gregorius, who knew I could teach before I knew. Thank you for the opportunity to teach that first encaustic class at Cabrillo Arts.

To R&F Handmade Paints, for providing much appreciated technical advice.

To Ampersand, for all of the Encausticbord panels for this book.

To all the fine paint makers and suppliers who contributed their beautiful and inventive products to this book and DVD: Clairvoyant Encaustics, Eco Green Crafts, Enkaustikos, Evans Encaustics, Jacquard Products/Rupert, Gibbon and Spider, Miles Conrad Encaustics, Northwest Encaustics, R&F Handmade Paints.

To Elaine Lipson, for being a skillful and knowledgeable editor. You have been a fantastic cheerleader and a delight to work with!

To Elisabeth Malzahn, for major marketing and great interview questions.

To Rebecca Campbell, for styling with humor and grace.

To Liz Quan, for being the quintessential art director.

To Joe Coca, for fabulous photography and having the most toys.

For all the students I have taught all around the world. You inspire me with your great encaustic leaps and pyrotechnics and make me wonder, *Why didn't I think of that?*

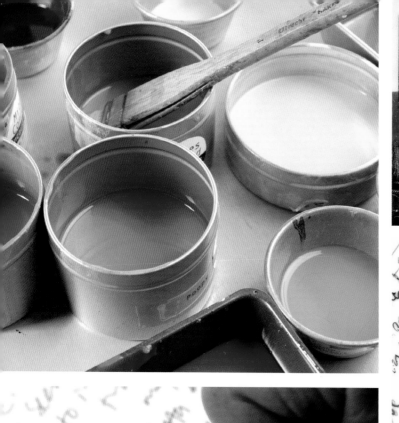
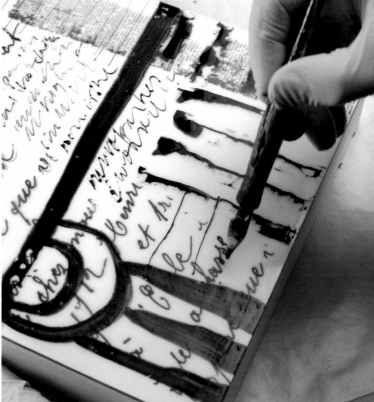
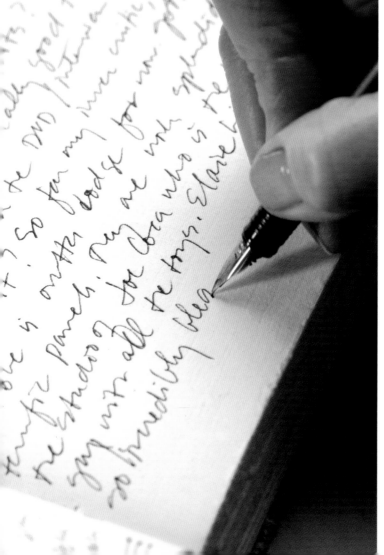
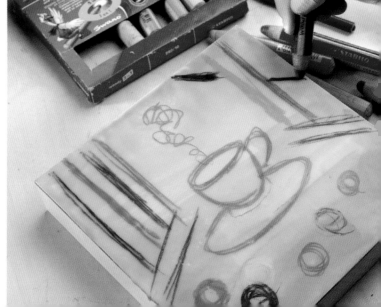

contents

a mixed-media dream *come true*

I have been making art for as long as I can remember. In junior high school, I took a ceramics class and won a summer scholarship to attend Chouinard Art Institute (later Cal Arts) in Los Angeles. My reward was a two-week Methods and Materials class, a precursor to a Mixed Media class. I learned to weld an armature, make papier-mâché, and work with plaster of Paris. In high school, the ceramics classes were full, so as my second choice, I took jewelry with Mrs. Lewis. My first aesthetic insight came from her. "If you do hearts, you fail the class," she warned, and ever since I've had a fear of "doing hearts."

I went to Haystack Mountain School of Crafts to study jewelry during college, but after hearing Walter Nottingham's talk, "The Magical, Mythical Qualities of Fiber," I was seduced by the fiber world. In the early 1970s, a time when the fiber world was bursting open, I went to the University of California at Los Angeles for a masters degree in textiles. There I crocheted room-size environments (we now call them installations), one of which was exhibited at the 1975 Tapestry Biennale in Lausanne. Since then, I have swung like Tarzan from one medium to the next.

Though I'd seen Jasper Johns' work using encaustic techniques in museums, it was in 2001 that I saw my first real encaustic paintings in a small gallery on Whidbey Island in Washington state. I had a primal, visceral reaction. Those two paintings, with their skinlike surface, pulled me to them like a string. When my speech returned, I asked the artist, "What is it and how do you do it?" All I heard of the reply was, "Beeswax and an iron." Back at home, I had no beeswax, but I had paraffin candles. I lit one and started dripping wax on paper and trying to collage and embed various items. I then put an iron to it, creating what I now know is a lot of toxic smoke.

I soon found out that there was a bible for all this— *The Art of Encaustic Painting,* by Joanne Mattera. Next I discovered R&F Handmade Paints and their regional workshops. I was in heaven! Eve-Marie Bergren, with a background in Ukoye printing, was my first teacher. I went on to the R&F factory in upstate New York where I studied with Cynthia Winika, who also had a background in textiles. These marvelous teachers gave me a thorough background in this versatile, ancient process. I have never stopped being in love with this medium. The more I work with it, the more I discover. The more I discover, the more I am in love. Usually I'm a pretty fickle girl, prone to jump ship and go to the next new thing, yet I've been faithful to encaustic for more than a decade. Today I teach for R&F, and also co-founded Wax Works West, a school for the encaustic arts, near Santa Cruz, California, with my partners Judy Stabile and Wendy Aikin (my first student).

For a mixed-media artist, encaustic is a dream come true. All the media I have worked in come together in grand profusion with encaustic. It has become the glue that holds everything together. As someone who is primarily inspired by materiality itself, this is the ultimate medium, incorporating whatever I care to throw at it! For those of you wanting to mix media, encaustic will help you embark on a fabulous adventure. In this book, I'll teach you what I know so you can work safely and with ease and fall in love with this ancient medium. A DVD is included so you can see my studio setup and see me demonstrate many techniques.

When I began doing encaustic, there was very little reference material available. Since then, I have witnessed an explosion of artists working in encaustic, and now there are many more resources. I am happy to contribute my own. With it, a spirit of exploration and adventure will serve you well. Enjoy!

Daniella Woolf

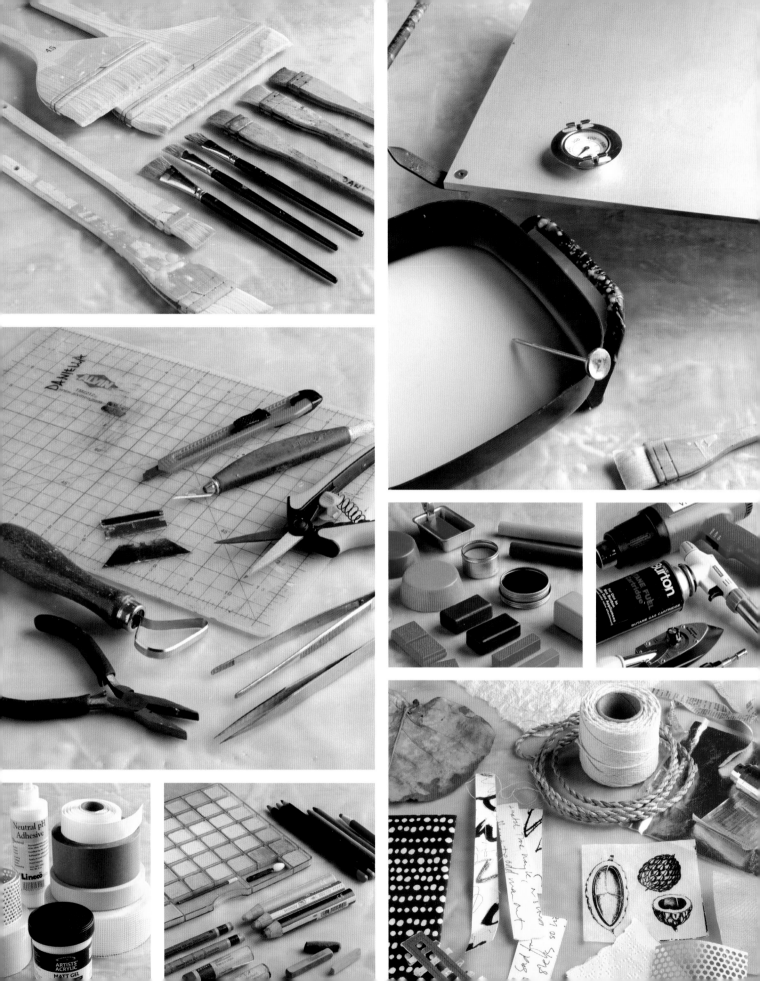

tools + materials

Artists working in encaustic love their tools and materials. I started off in a modest way with palettes and electric woks from the thrift store and then moved up, treating myself to something new every month or so and building my studio slowly. You can do fantastic work with humble equipment! The first tools you use will always make you feel confident and comfortable. For example, I was trained to apply paint with a split-shank hake brush and I still do today. When a friend raved about angled hog-bristle brushes, I found that I really like those, too. Be creative and explore every possibility—there are potential tools and materials everywhere!

basic encaustic tool kit

If you're just getting started with encaustic, you'll need these basic tools and materials to begin. This list will allow you to start making art right away with just a minimum of equipment. You'll need this tool kit for the techniques and projects in this book; only additional tools and materials specific to the technique or project are listed in the instructions.

- Metal worktable or surface (try large oil-pan trays from an auto supply store)
- Electric palette or pancake griddle
- Flat thermometer for the palette or griddle
- Electric skillet to melt medium or beeswax
- Candy thermometer to measure wax temperature in the skillet
- Flat-bottom metal containers for paint and encaustic medium (muffin tins will work if level and flat)
- Torch or heat gun
- Natural-bristle brushes
- Encaustic paints
- Encaustic medium
- Substrates: rigid, absorbent painting surfaces such as cradled panels, plywood, or wood without any polyurethane or other coatings
- Blue painter's tape
- X-Acto knife or box cutter for cutting and trimming paper and tape
- Self-healing cutting mat for use with X-Acto knife or box cutter
- Paper towels (I like Viva brand) or soft cloth rags
- Vinyl gloves, nitrile gloves, or barrier cream
- Vents or fans to exhaust fumes and provide cross-ventilation in the studio
- Fire extinguisher

important safety tools

See page 36 for detailed information about necessary safety precautions. Protect your skin, hands, and lungs from toxic substances and from fumes. When setting up your studio, ventilation is extremely important. Melting wax releases fumes that must be drawn out and away from you. If possible, have your palette close to a window with a box fan that will exhaust fumes out the window. The fumes contain toxic components (just as the air we breathe contains carbon monoxide), but the fumes themselves aren't toxic unless the wax is overheated and the concentration of toxic components reaches a harmful level. Below that level, they are irritants at most. To maintain a safe studio, always keep your palette at or below 200°F (93°C) to keep the paint molten without generating smoke (no respirator can successfully filter out the various fumes that smoking wax generates). Always protect your hands either with gloves or barrier cream.

Vinyl Gloves, Nitrile Gloves, or Barrier Cream

I like to use nitrile gloves, which offer latex-free protection for hands from pigment, paint, and the heat of a very hot palette. Vinyl or nitrile gloves are a must when working with pigment sticks. You'll find them at hardware stores, big-box discount stores, and some grocery stores and drugstores. If you don't like to wear gloves, use barrier cream, a water-soluble cream that you apply like hand cream.

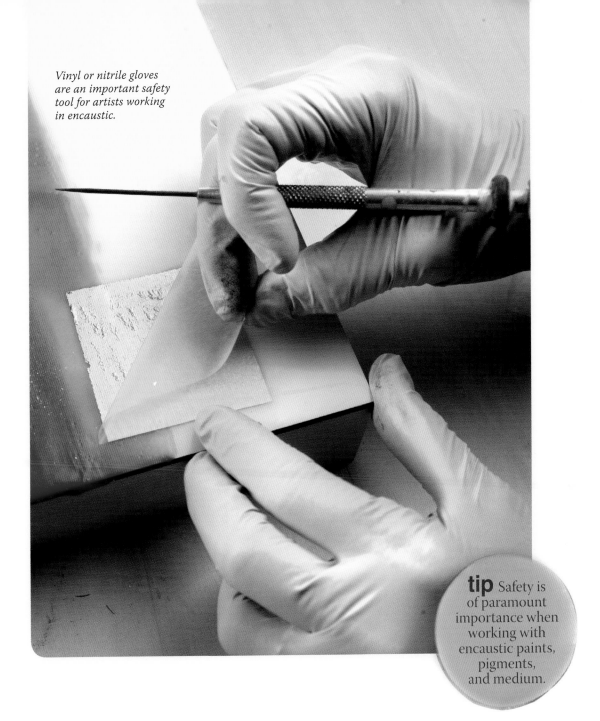

Vinyl or nitrile gloves are an important safety tool for artists working in encaustic.

tip Safety is of paramount importance when working with encaustic paints, pigments, and medium.

Fire Extinguisher

It is absolutely essential to have at least one fire extinguisher in your studio.

Water

Always have a bucket of water at room temperature in your studio. If you burn your fingers, immediately submerge them in water.

Fresh Tomato, Aloe Vera Plant, or Chinese Burn Cream

Be sure to have something to apply to a burn. For a natural approach, I like fresh tomato slices, aloe vera gel, or Chinese herbal burn cream. Seek medical attention immediately for serious burns.

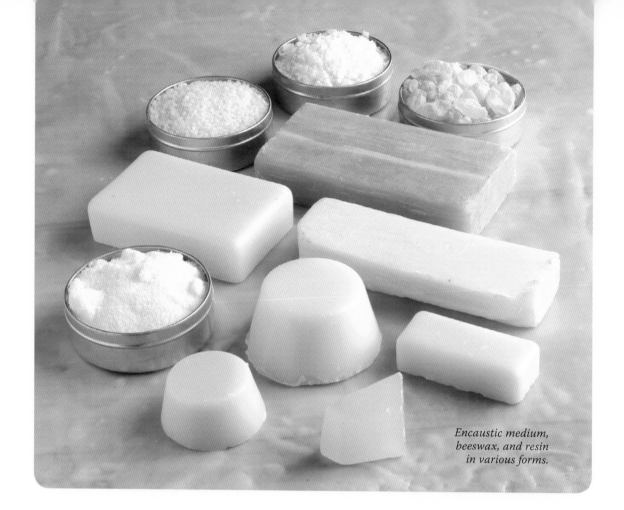

Encaustic medium, beeswax, and resin in various forms.

encaustic medium, paints, and pigments

Encaustic medium is the basis for all encaustic work; we call it wax, but it's a blend of beeswax and damar resin. Encaustic paint is pigment in a base of encaustic medium. Both medium and paints go on the substrate in a molten state and dry very quickly. Encaustic medium can be the glue that holds any mixed-media project together, and encaustic paints are versatile and beautiful, whether applied in thin translucent layers and glazes or full strength for a luscious and bold appearance.

Medium

Encaustic medium is sometimes just referred to as wax, but is actually a blend of **beeswax** and **damar resin**, a natural tree resin. In this book, medium always means encaustic medium, not the many mediums made for painting (unless specified as acrylic gel medium for a technique

or project). In encaustic medium, ratios of beeswax to resin vary; the blend I use is nine parts beeswax and two parts resin.

Damar resin enhances and improves beeswax, raising the melting point from 146° to 160°F (63° to 71°C) and hardening and stabilizing the wax. It helps the beeswax to resist dust and adds a lovely translucency and shine to the wax while preventing blooming, a white film that can occur on the surface. Use a soft cloth or Viva paper towel to buff and polish encaustic medium after it has cooled, and you'll begin to see into the layers with more clarity. Damar resin has a sort of living quality to it; it takes about a year to completely cure, and during this curing time, a surface will return to a matte finish even after buffing. When fully cured, the surface will hold a shine.

If you're a beginner at encaustic, I recommend that you buy medium from a reputable maker (see Resources, page 156); you have enough on your plate without making your own medium. If you advance to making your own medium, be prepared; it takes many hours to cook, as the damar resin is quite sticky and takes a long time

to be absorbed into the beeswax. Never heat medium to more than 230°F (110°C), or it will be above a working temperature. It's best to cook it outdoors. Some artists prefer to work with other ratios, such as eight parts beeswax to one part resin; the more resin, the more hard or brittle the wax becomes.

Encaustic Paints

Encaustic paints are pre-made blends of encaustic medium and pigment. These paints are available in a rich array of colors that range from translucent to opaque. Metallic and iridescent formulas are also available. Encaustic paints dry almost instantly and should be fused with heat after each layer of application. The versatility of encaustic paint is unparalleled; thin with medium for a more glazed effect, or use full-strength for dimensional and textural applications.

Oil Sticks and Other Pigment Tools

In addition to encaustic paints, many other materials can add color with encaustic methods; I describe a few of my favorites here, and you'll see various other materials, such as graphite pencils, used in the pages that follow.

+ Oil sticks are composed of a small amount of beeswax, linseed oil, and pigment. I use the Pigment Sticks brand made by R&F Handmade Paints. Use oil sticks on or beneath the surface of an encaustic painting. They are especially lovely if you have air bubbles or marks on your surface. Apply pigment to the marked surface and fuse it, or leave it to stain the surface, or wipe it off to create layers of color. It is important to wear vinyl or nitrile gloves or barrier cream to protect your skin when using pigment sticks. (While oil paint doesn't hurt the skin, it can be hard to clean off, increasing the danger of ingesting pigment through food.)

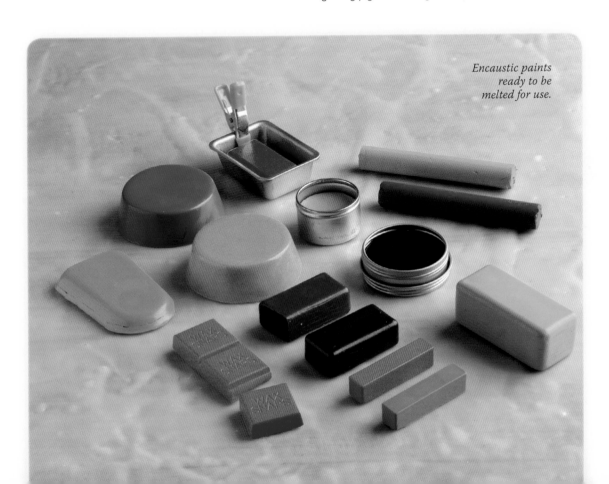

Encaustic paints ready to be melted for use.

+ Chalk pastels or pan pastels can be used to deposit pigment directly on the wax. Look for high-quality pastels; they'll contain more pigment for richer results. Rub the powdered pigment into the surface and fuse so that the pigment bonds with the wax (see page 102).

+ Perfect Pearls Mists is a product with liquid metallic pigment in a spray bottle. Spray it onto a wax surface as a top layer and do not cover with medium for the best effect.

+ India ink comes in black and a variety of colors. Use it to draw directly on a wax surface. When brushed on in thick strokes, it can dry in unpredictable patterns. India ink can be your top layer if allowed to dry completely. You can let it dry a little and use it to stain the wax; you can scratch it back; you can paint medium over it and have it be one of many layers.

+ Watercolor pencils with a wax content such as Stabilo pencils, Caran d'Ache Neoart, Caran d'Ache Neocolor II, a Lyra 9B graphite pencil, or simple china marker are all effective for drawing on an encaustic surface. Blend these pigments or remove them with water. Fuse after application.

Encaustic Gesso

Gesso is a paintlike product that seals a substrate and provides a consistent ground for additional layers; using gesso is one way to create a white surface (see page 39) on a wood panel. Oil and encaustic painters traditionally used rabbit-skin gesso to create a white ground. Today, it's much easier to use a pre-made gesso

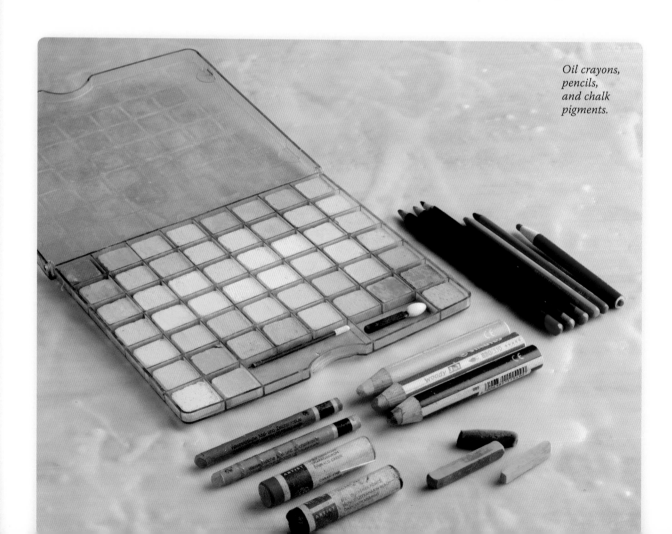

Oil crayons, pencils, and chalk pigments.

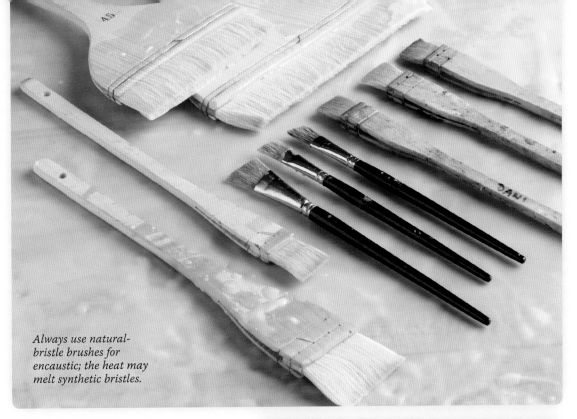

Always use natural-bristle brushes for encaustic; the heat may melt synthetic bristles.

formulated for encaustic work. A white ground will enhance the colors of additional layers of encaustic paint, though you can also find gesso in black and other colors that can act as an inexpensive underpainting before applying encaustic medium.

brushes

For encaustic work, you must use **natural-bristle brushes.** Synthetic ones may melt. I use a variety of brushes; the most specialized are hake and split-shank hake brushes. These come in widths from 1" to 7" (2.5 to 18 cm). Hake brushes, usually made of goat hair, hold a lot of paint and will apply the paint in a smooth and even fashion; I have a selection of these in my studio. Wider brushes are ideal for sizing a panel. I also use angle-tipped hog-bristle brushes for cutting in shapes. Inexpensive brushes from the paint section of the hardware store are quite coarse and will create more texture and a rougher surface than more expensive natural-bristle brushes.

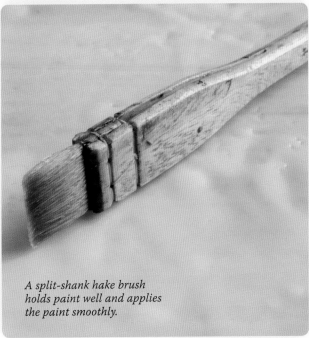

A split-shank hake brush holds paint well and applies the paint smoothly.

heating and melting tools

A key tool for encaustic is an apparatus that will heat evenly to melt your paint, maintain its temperature, and keep your brushes hot. If your paint is hot and your brushes are cool, the paint won't go on smoothly. Here are my recommendations.

Palette

An **electric palette** heats your paints and encaustic medium to the correct temperature and warms brushes and tools. Paint melts at about 160°F (71°C); for the paint to be molten, the palette usually is held at 200°F (93°C). The best encaustic palettes have thick anodized aluminum tops. The anodized surface holds the heat well, prevents pigments from staining the palette, and shows the true color of the paint. Palettes for encaustic painting are available in different sizes; some have brush and tool rests.

Skillet

A **common skillet (or electric wok)** is useful for melting in a variety of situations, such as when you need a lot of medium or beeswax for sizing your panels or pouring surfaces. You can also use a wok or skillet if you choose to make

Skillet (below) and electric palette for heating and melting. Note the flat thermometer resting on the palette.

your own medium. Use a candy thermometer to make sure the temperature stays at an optimal 200°F (93°C).

Roland HOTbox

The Roland **HOTbox** is a constructed wooden box that is electrified. The interior has four 100-watt lightbulbs and a rheostat with an anodized aluminum top that slides on and off. The HOTbox is useful for encaustic monotype and can also be used for painting. To work on large pieces, gang palettes or HOTboxes together modularly to make a larger palette surface.

Griddle

A **pancake griddle** is an inexpensive and good alternative to an anodized aluminum palette. A griddle can be just as efficient, is lighter in weight, and is easy to obtain. Look for one at big-box stores, thrift stores, or yard sales. Most have a temperature control, which may be inaccurate. It is important with a griddle, as with all hot palettes, to use a flat thermometer on the surface to make sure you are not heating over 220°F (104°C). Griddles are relatively light in weight, with a heating element inside the unit.

Thermometers

Accurate **thermometers** are a must in the encaustic studio. On flat surfaces such as a palette, use a flat thermometer, as many built-in thermostats are inaccurate. You should also have a candy thermometer in your tool kit to check the temperature of melting encaustic medium in a skillet.

Metal Containers

Have a number of **flat-bottom aluminum or stainless steel containers** for melting paint. They can be round or rectangular and should not be too large or too high. Small muffin or bread tins work, or you'll find tins made for this purpose at art-supply retailers. Aluminum containers are usually not anodized, so they can cause discoloration of paint if scratched. Cups made of an aluminum and steel alloy are well suited for containing encaustic paint.

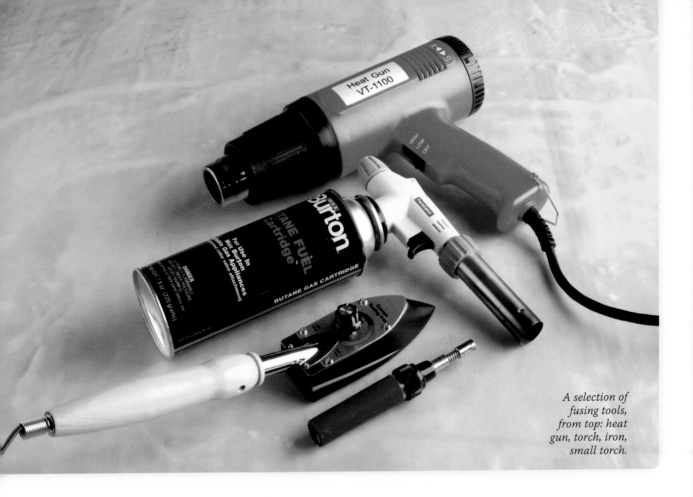

A selection of fusing tools, from top: heat gun, torch, iron, small torch.

fusing tools

Fusing each layer of medium or encaustic paint is a key technique for successful encaustic work. Fusing integrates the layers and creates lasting, beautiful, archival work. As with heating surfaces, you have several choices of tools for fusing.

Torch

When I began to study encaustic, I was taught how to fuse with an open-flame torch as well as with a heat gun. I learned to identify the right tool for the right job; with experience and practice, you will, too. I'm more comfortable with an open-flame torch. In my classes, people who've worked in lamp-bead glassworks find the torch easy to use and have no fear. Others begin with a heat gun and never try anything else. While it's worth experimenting to find what you like best, you can achieve similar results with most tools. Following are some of the torches I've worked with. For fuel, butane and propane are suitable for encaustic work.

+ My favorite is the **Iwatani torch** head used with a butane canister. You can produce a range of the flames with its adjustment dial, so if you can have only one torch, this is it! The disadvantage is that sometimes you can't find the correct butane canisters in remote places, but some online retailers will ship them if you can't find them in your area.

+ The **Bernz-o-matic TS 4000 trigger-start torch** head (with a blue propane fuel tank) has a trigger that lets you stop the flame instantly. This torch's disadvantages are that it is a bit unwieldy and the flame is not adjustable. It can cover a lot of surface territory in a short time. Some artists who are working large use one in each hand!

+ Look for **small crème brulee or "pencil" torches** at hardware stores or restaurant supply stores. I've had luck with Bernz-o-matic, Chefmaster, and Ronson Tech Torch brands. These produce a very small flame and are good for tiny fusing areas, getting into small places, or when you need a very small amount of flame. For example, they are just right after

17

burnishing a photocopy or toner-based transfer when you have a small residue of paper left on the surface; you can lick the surface with a tiny flame so that the wax comes up and encapsulates the paper. Butane refills are available at hardware stores and sometimes at gas stations with larger stores.

Heat Gun

A **heat gun** usually has a temperature-regulating wheel and some have a digital temperature read-out. Most have a switch for "blow" or "air" options. Always choose the gentler (air) speed; the higher blow speed can distort the surface of your work. A heat gun's temperature can reach as high as 1,100°F (593°C) in the metallic part. Never touch the metal portion—it can give you a second-degree burn or worse.

A heat gun is good for fusing the surface of a panel, and the heat is more diffuse than the concentration of an open-flame torch. A heat gun is best used with materials such as paper that might burn if fused with an open flame. Please note: a hair dryer is not the right tool for fusing. It will not get hot enough and it may blow too much air, destroying the surface of the work.

Iron

When you fuse with an iron, the paint tends to get distorted and scattered, but as with all tools, you can become proficient with practice. The irons that Jasper Johns is purported to have used are similar to small kimono or travel irons. If you use an iron as a fusing tool, it should not have steam holes. Look for these types of irons to try:

+ **Ski wax iron.** You can use an iron made to apply ski wax. Again, temperature is of utmost importance. Use a temperature regulator or a flat thermometer to ensure the correct temperature.

+ **Encaustic iron.** Look for an iron made especially for encaustic, such as the Handi Encaustic Iron; it's a small, light iron with an excellent thermostat and polished base plate.

+ A **tacking iron** is designed for adhering photos to a substrate, but usually runs at too high a temperature for encaustic, and must be turned down to about three-fourths of its full capacity on the dial. It's good for fusing and for making a very smooth surface. It will mix your colors on the surface. Use paper towels folded in quarters to wipe the iron off every time it goes across the surface of your wax so it does not smoke. You can also use a tacking iron to iron off the excess wax on the sides of cradled panels.

+ A **small quilting iron** works well for encaustic. This type of iron should also be used at about a three-fourths setting on the dial, or it will run too hot for the wax.

+ An **iron attachment** is available for use with a hot wax stylus pen. This is an excellent tool, especially for collage. The teardrop-shaped iron attachment is small, measuring about 1" × ⅝" (2.5 cm × 1.5 cm).

Hot Wax Stylus Pen

A **hot wax stylus pen** comes with stylus, brush, and iron attachments and can be used in many different ways. One of its sterling advantages is that its temperature is set at the ideal 200°F (93°C). Use the stylus tip to write, draw, and make dots and lines, or the brush tip to paint brush strokes with no additional fusing necessary. The iron tip works splendidly for collage with thin papers such as napkins. Woodburning tools with attachments can be used in ways similar to hot wax stylus pens, but they are set around 600° to 900°F (315° to 482°C) and create a lot of toxic smoke. It is imperative to use a temperature regulator with woodburning tools.

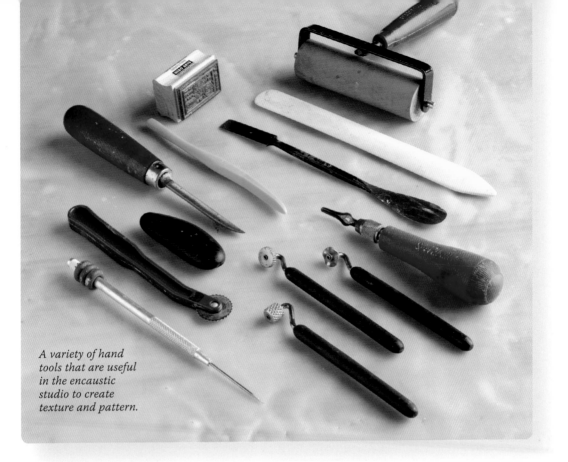

A variety of hand tools that are useful in the encaustic studio to create texture and pattern.

hand tools

Many objects make wonderful hand tools for encaustic work. Collect as many different tools as you can and consider everything as a possibility. The following tools have found a home in my studio.

Burnishing Tool

A **burnishing tool** can be metal or plastic; it's used for firm and even rubbing. I use a burnishing tool for transferring imagery such as toner-based prints, rub-on type, and some metal leafing products. If you don't have a dedicated burnishing tool, use the bowl of a spoon or a smooth stone.

Bookbinder's Awl

This is a **pin-shaped tool** with a metal point that is useful for scoring, pricking, and texturing wax. Use it with stencils to delineate shapes or letters.

Bone Folder

Made of bone, plastic, or Teflon, a **bone folder** is a tool used by bookbinders to score and fold paper; for encaustic, it also works as a burnishing device.

Pottery Tools

I use a **kidney-shaped LT-5 wire-end scraping tool,** made by Kemper Tools for potters and ceramicists, for scraping back the surface of my wax. It has a very sharp blade that can be sharpened with a file when it gets dull. Be careful when you clean the scraping tool—wipe parallel to the blade so you don't cut yourself. Look for an assortment of pottery tools, as they can be very useful in the encaustic studio for scraping, incising, and carving.

Linoleum Cutters

These tools incise lines into the wax. They are available with **U- and V-shaped grooves.** Carve out shapes in the wax (which you can then fill with a contrasting color of wax).

Rolling Print Wheels

Look for **rolling sewing markers, ravioli cutters, or other metal rolling wheels** with patterns. Use them with metallic foil transfer techniques and for creating a pattern of depressions in an encaustic surface that you can then fill with paint or pigment stick.

Stamps

Stamp into the surface of the wax with **rubber, metal, plastic, or wood stamps;** avoid clear acrylic stamps, which are less successful with encaustic technqiues. After stamping, fill the depressed area with paint or pigment sticks if you like. When stamping into the surface of the wax, you need a release agent such as vegetable oil on the surface of the stamp so that the stamp does not stick in the wax and pull back the surface.

Stencils

Many **ready-cut plastic or paper stencils** are available, or cut your own from sheets of acetate such as those used for overhead projectors, or from blue painter's tape, or freezer paper. Run a burnishing tool or brayer over the stencil so that you have good adhesion to the wax surface before painting.

Shims

These can be rectangles of cardboard or illustration board, or old credit cards (it's a great way to use the fake credit cards that sometimes come in junk mail). **Shims** are versatile items in the studio, good for stabilizing a palette leg, scraping away excess wax in a collage, and other uses.

substrates

A substrate, or surface on which to work, can be anything that is both rigid (hard) and porous. Both characteristics are important to successful encaustic work; porosity helps the wax bond with the substrate, while rigidity helps prevent ripples and waves from cracking the surface of the completed artwork. Purchase substrates made especially for encaustic, or search out wood, stone, paper, or other surfaces. Following are some of the best options.

Wood

Wood, as a surface both rigid and porous, makes a wonderful substrate for encaustic work. Make friends with the woodworkers at a local cabinet shop; they may have small pieces

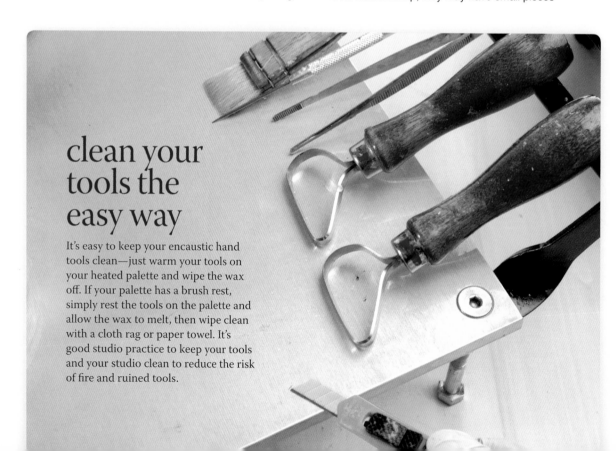

clean your tools the easy way

It's easy to keep your encaustic hand tools clean—just warm your tools on your heated palette and wipe the wax off. If your palette has a brush rest, simply rest the tools on the palette and allow the wax to melt, then wipe clean with a cloth rag or paper towel. It's good studio practice to keep your tools and your studio clean to reduce the risk of fire and ruined tools.

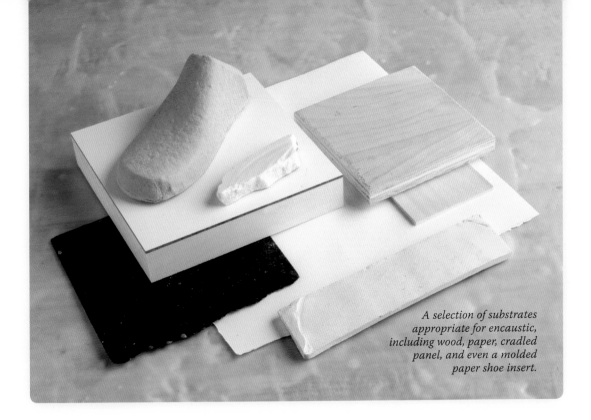

A selection of substrates appropriate for encaustic, including wood, paper, cradled panel, and even a molded paper shoe insert.

of wood available for you to recycle and reuse. Avoid wood that has a protective finish such as varathane (heat could release toxic fumes).

+ Plywood. Plywood is an inexpensive wood; buy a sheet and have it cut into the sizes you need. I recommend Baltic birch ply, as it is strong and light in color.

+ Cradled panels. A cradled panel is a wood support with deep sides. The larger the panel size, the more bracing it needs to prevent warping; cradles may be ½" to 6" (1.3 to 15 cm) deep. These panels are available from many art suppliers, and your local cabinet shop may be willing to make cradled panels for you.

+ Encausticbord, made by Ampersand, is a brand of panels and cradled panels prepared with encaustic gesso and ready to paint. I used Encausticbord for most of the demonstrations in this book. They work quite well if first heated on a palette, face up, and sized with two coats of medium. If you use Encausticbord without heating first, use four coats of medium to size the panel and get a smooth surface.

Paper

Paper will work for encaustic as long as it does not have a shiny coating on it. In keeping with the rule of substrates that are both rigid and porous, try cast paper, illustration board, or museum board. Encaustic paint or medium seems to strengthen thick paper but weaken thin paper.

Miscellaneous Substrates

Other substrate options include **unglazed bisque-fired ceramic, bone, stone, cast concrete, marble, and canvas glued to a substrate.** If very small (no more than 3" × 3" [7.5 × 7.5 cm]), you might have success with metal, stretched canvas, or roofing tarpaper.

Drywall Mud

Drywall mud, also called joint compound, is a useful and inexpensive product for obtaining a white ground on the first layer of a substrate or for creating a textured surface. Simply apply with a trowel and allow it to dry, then paint with medium.

tapes and adhesives

Tapes and adhesives are very useful and versatile in the studio. These are the ones I use most often and find indispensable.

Blue Painter's Tape

Look for **blue painter's tape** for delicate surfaces, available in a variety of widths. I use it to protect the sides and back of cradled panels as well as to mask lines, make stencils, and create shapes on wax surfaces. To easily remove the tape from the sides of a cradled panel, heat the sides with a heat gun. If you don't take this step, the wax may chip back into the face of your panel as you remove the tape.

Document Repair Tape

This **acid-free, lignin-free tape** is expensive and well worth it. It is very thin yet strong, has just the right tack, is pH-neutral, and is hardly visible when waxed. It is permanent with a non-yellowing adhesive. It's primarily used for the repair of tears and other damage to paper art, documents, maps and artifacts. I buy this tape in rolls of 1" × 35' (2.5 cm × 10.5 m).

Perforated or Gridded Drywall Tape

I use both of these tapes as stencils to make patterns on wax. They work well because they have a bit of a tack to them, so they stick well onto the wax without much bleed of paint under them.

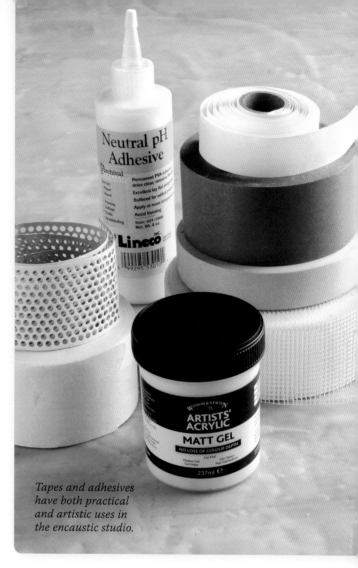

Tapes and adhesives have both practical and artistic uses in the encaustic studio.

PVA glue

I use **Lineco brand PVA glue.** Made for bookbinders, this pH-neutral glue works well when adhering paper to a substrate. Coat the paper and the substrate with glue until both are tacky, then adhere, making sure the paper overlaps the substrate. Cover with wax paper and weight under something heavy for twenty-four hours.

Acrylic Gel Medium

This is my preferred adhesive for gluing paper to a substrate. As a rule, acrylic and wax are not compatible, so this may be confusing. The acrylic medium remains between the paper and the substrate, underneath the wax surface, so there is no acrylic touching the surface of the wax.

useful extras

These handy items help make life in the studio easier, or offer inexpensive options for adding texture or pattern. You'll find many things to add to this list as you work in encaustic.

Razor or Utility Blades

I buy blades in packs of 100 for scraping back the surface of the wax after filling a stamped or incised area. I use as many blades as it takes to do the job. I like to store them next to my palette on a magnet ring for safety. I clean them all at once, putting them on my palette, letting the wax melt off, then removing them, wiping them off with a paper towel or soft cloth rag, and allowing them to cool before I use them again.

Box Cutter

This versatile, lightweight, humble tool is my answer to a happy life. It opens most packages, cuts cardboard shims and most other things, and trims the edges of paper that is adhered to a panel. **Box cutters** are inexpensive with easily replaceable blades.

X-Acto Knife

I use an **X-Acto knife** with a No. 11 blade. I buy these blades in quantity and use them for trimming the ends of paper adhered to a panel, cutting stencils, and removing debris from the wax surface. Change the blade often to keep the edge sharp. X-Acto knives are inexpensive and are available at any art supply store or hardware store.

Tweezers

These are handy for moving and removing paper when you are doing collage work right on your palette, or to hold paper that you are dipping into a vat of medium.

Waxed Paper

Waxed paper is useful in the studio as a barrier between paper and burnishing tools so wax does not get on your tools. It also works well protecting the face of your work when packing it for shipment.

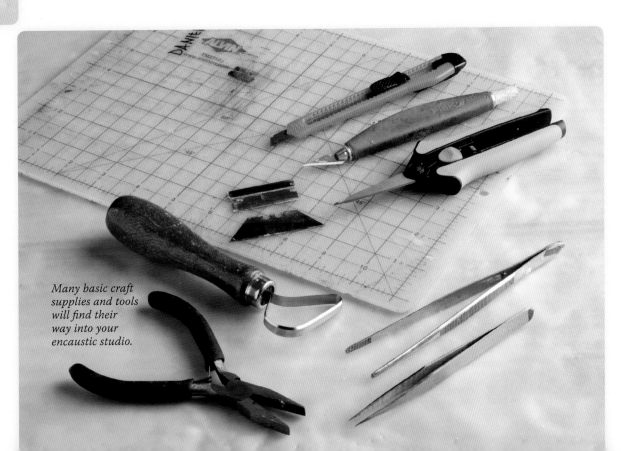

Many basic craft supplies and tools will find their way into your encaustic studio.

Almost anything goes when it comes to using found and reclaimed objects in encaustic collage—be creative!

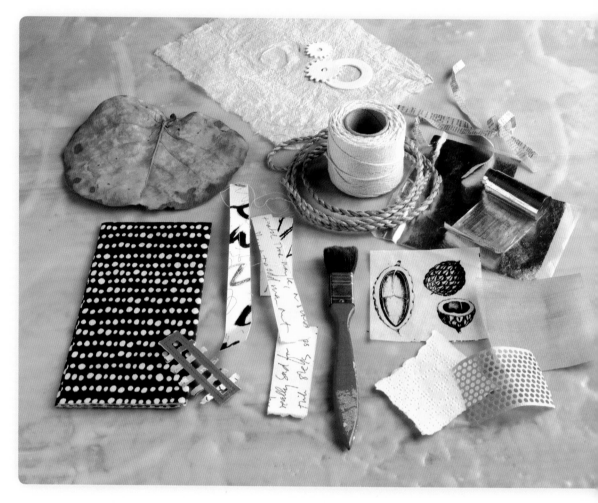

Freezer Paper

Available in grocery stores, **freezer paper** can be used to cut stencils. Place a sheet with the shiny side on the face of your work as a protectant when shipping work, or to protect the table when working with encaustic on paper. Its shiny surface doesn't stick to wax.

Oil-Drip Pans

Metal pans from the auto-supply store make a good work surface. They catch wax and paint drips and protect your countertops—much less expensive than cladding your worktables with stainless or galvanized steel.

Self-Healing Cutting Mat

If you're frequently trimming papers for use in encaustic collage, a **self-healing cutting mat** is useful to protect your worktable and provide a smooth cutting surface.

Linseed Oil and Soy-Based Cleaner

I use **linseed oil** (with proper safety precautions for disposal, as described on page 84) as a release agent for stamps. I use **SoySolvII,** a soy-based cleaner, for cleanup.

SCRAP creative reuse center

Looking for hidden and unexpected treasures to use in your mixed-media encaustic work? Along with hunting and gathering at thrift stores and yard sales, see if your neighborhood has a creative reuse center—a repository for goodies. In San Francisco, for example, there is a wonderful place called SCRAP, which calls itself a "non-profit creative reuse center, materials depot, and workshop space . . . SCRAP breathes new life into old objects and reduces waste by diverting over 200 tons of materials heading to landfill every year."

Teachers and artists visit SCRAP to buy all kinds of things appropriate for art projects, donated by companies and individuals. Visit scrap-sf.org to check it out, then see if your city has a similar project—or think about starting one in your spare time!

found and reclaimed items for collage

In my encaustic work, I use a wide variety of found and recycled objects, and I encourage you to do the same. Remember that, if used as a substrate, objects must be rigid and porous. Many kinds of objects can be attached to a substrate, coated in wax, or otherwise collaged to a substrate. This is the heart of mixed-media art—use your imagination and consider everything. A few notes about specific types of objects follow.

Plants

All **plant material** is fair game, but must be dried. If you are embedding or using leaves in collage, for example, they must be dry. If you embed wet or "green" plant material under wax, it may grow mildew. If you're in a hurry, dry plants in the microwave.

Fabric

Wax makes textiles darker and more saturated in color. I recommend using **lightweight and light-colored fabrics.** The semitransparent wax will appear milky white when applied over a dark fabric.

Paper

Paper must be porous to be used successfully in encaustic work. Some printed papers, such as postcards, magazines, and old photos, have a shiny surface. These are not porous, and the wax will not adhere to slippery, shiny surfaces. You can sand the finish off these papers, but it will change your imagery—though you might like that, especially if you put something beneath that paper that has a raised or patterned surface. The pattern will transfer to the sanded surface.

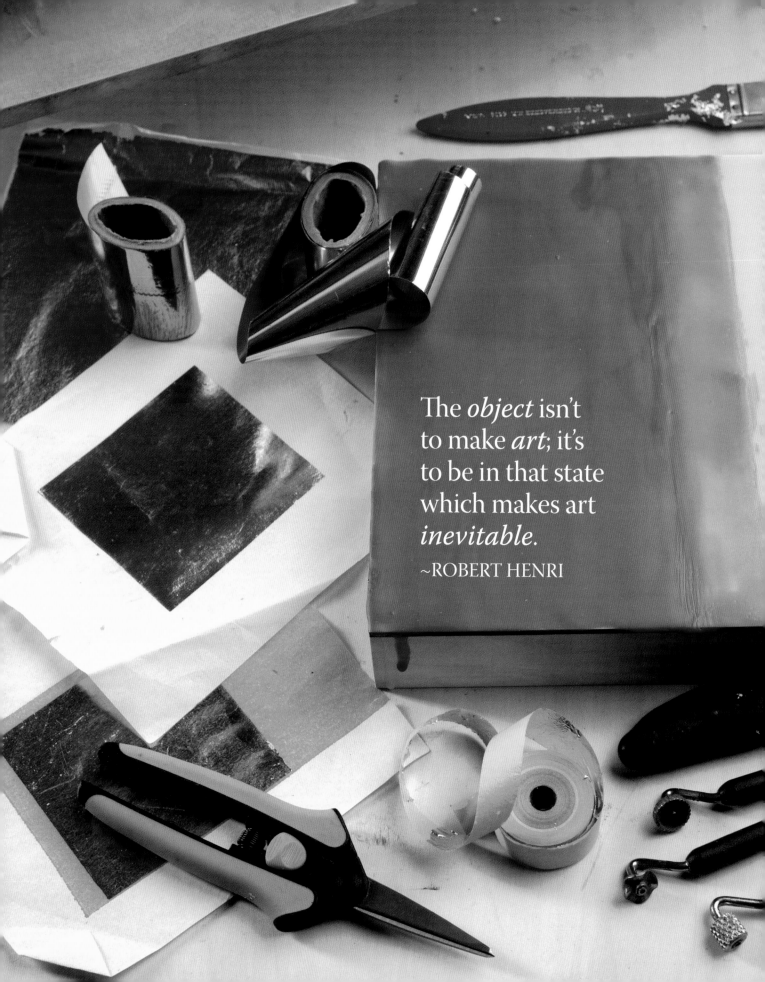

The *object* isn't to make *art*; it's to be in that state which makes art *inevitable*.

~ROBERT HENRI

studio practice +creativity

The basic methods of encaustic aren't difficult; anyone can learn them, and with time and commitment, begin to master them. In this chapter, I introduce you to some of my thoughts about daily art practice, setting limits to generate greater creativity, color, and visual thinking. Art is a lifelong journey with many detours along the way, but we can learn from the guideposts of others' experiences. I hope my ideas here will help you to make art that is original and truly yours in the most satisfying way.

the value of practice

There is something to be said about creating in a naïve state. We come up with something that we've invented or constructed, while we're in the zone that Robert Henri mentions in the quote on page 26. Then we spend the following days, months, or even years trying to re-create what we did in that zone. We usually can't, but we are determined, driven, and on the trail. We keep trying to make the kind of work that was birthed in this state, but it never seems to be as good as that original, magical work of wonder.

We want to be in that place where there is no time or space, and we even forget about food (good luck)! The feeling we're after is almost as if we are not in charge, but simply taking dictation from some greater source. But how do we get there?

Some of it is intuition. I have evolved a simple but consistent and well thought-out practice—things that I do on a regular basis. When I am not traveling, I have a daily schedule. I exercise in the morning and do my brainy things early in the day, when my left brain (size of a lentil) is more engaged. I work in the studio and on creative things in the afternoon and evening with my right brain (size of a watermelon).

I also use techniques that Julia Cameron introduced to many artists in her book *The Artist's Way*. I journal every day, which helps me to check in on a few things: Where am I? What is on my inner critic's mind? How loud is her voice? What do I need to do to escort her out of the studio? And I go on an artist's date once a week to feed and inspire myself and refill my treasure chest of ideas.

■ *Library Card Mobile (see enclosed DVD)*

creativity and the power of the container

I have been gifted with a wildly fertile, actively creative mind. I look at an object, a pattern, a tree, whatever, and my mind goes to town and morphs, morphs, and morphs. I love to be in that creative place; maybe it's similar to the experience of meditation for some. However, if I don't put a harness on it, it can run away with me or paralyze me. I have learned to limit my options, perhaps by color, pen, or medium, but there must be some parameters for my work.

I call this *having a container.* In some ways, it doesn't really matter what those parameters are, but simply that they exist. If I give myself free rein and infinite options with which to create, I can't move. The world is too big. But if I give myself a few limits, I am golden. I can soar and fly and go completely wild within this container.

Before my grandson was born, I spent every December alone at my studio on Whidbey Island in Washington state. I called it my Greta Garbo festival, telling everyone "I vant to be alone." To make the most of these studio retreats, I'd pick a project or give myself an assignment for the month, with limitations that would force me to explore new territory.

For example, one December, I put these parameters in place: I would work only with black pens, white paper, and two paper shredders. I had a cross-cut shredder and a continuous long-cut shredder. With these simple implements, I developed a new vocabulary for myself. My handwriting and mark-making looked different with just a change of the gauge of the pen or the scale of the work.

Challenge yourself to work with limits.
Whether you restrict your selection of materials, colors, or themes, see how far you can go in your art with fewer inputs. Limits create a container for your work that will allow you to explore ideas in depth and go beyond what you think you know about the things you have at hand.

color

Many artists are drawn to encaustic because of the rich, deep, saturated color that it's possible to achieve with wax and pigment. Though color gives us a visceral reaction, there's a lot of science and theory to it, too. The more I work with color, the more I realize that there's a lot that I don't know, even after a lifetime of working with color and studying color theory. Color in context changes everything.

I remember walking into the studio at the R&F Handmade Paints factory for the first time and seeing a huge wall of color. Every gorgeous shade of encaustic paint was there and available to me with no limits. Earlier, in the company's conference room, I had been struck by a black-and-white painting by Don Maynard. I had such an affinity for it. I had seen his work in *The Art of Encaustic Painting* by Joanne Mattera (Watson-Guptill, 2001), and loved it, but in person it really spoke to me. I explored working with only black, white, and encaustic medium for some time. Today, I still use those parameters, but I also sometimes work with color. I like to choose colors that are analogous, or next to each other on the color wheel, and their opposites (split complements).

■ *Encaustic Transfers*

For this book, in addition to the black and white I normally use in my work, I chose a color palette of two greens, a turquoise, an orange, and a red. All these colors work in concert, as analogous colors on the color wheel or as split complements. As you'll see in these pages, that basic palette can produce tremendously varied results. You don't need every color in the paint catalog; a smaller palette can challenge your skills and teach you how fundamental colors interact.

commitment

Success in any creative medium takes time and commitment; encaustic is no different. Take your art seriously, find a space that you can dedicate to your art, and give it your time and energy on a regular basis. If you can't be in the studio every day, try to at least show up on a consistent schedule. You'll be amazed at how you improve, and how ideas generate more ideas when you provide physical and mental space for your art on a regular basis.

Put in the Hours

A smooth surface is one of the hallmarks of encaustic, and one of its sterling qualities. It takes some practice; it took me two years to figure out how to achieve the smooth results I wanted. In *Outliers: The Story of Success* (Little, Brown & Co., 2008), author Malcolm Gladwell theorizes that it takes 10,000 hours of practice to be successful at anything. When showing students how heat affects texture when sizing a panel, I'll ask if they've read Gladwell's book. I tell them that if they had put in as many hours as I have with a brush and encaustic medium, they would achieve a smooth surface (and probably better and faster)! This is true for many aspects of being an artist, and especially for becoming a good practitioner of encaustic.

There is something that happens in our bodies when we put in the hours. Confidence appears, fear lifts, and we have a sense of empowerment and the illusion of control over the medium. I am not sure if there is a substitute for repetition and practice. One day the process becomes easy and natural, and you'll wonder why it was so hard at first.

Don't be discouraged if your initial efforts don't match your vision. Keep making art consistently; put in the hours and don't worry about the outcome. Do what's necessary to make room in your life for time in the studio.

Schedule Studio Time

In one of my many jobs, I had a boss who said to me, "There will always be more work than we could ever do! Do what you can accomplish for today. The work will still be there tomorrow." When he said that, it removed a lot of guilt and anxiety. I sometimes think that all my commitments will conclude at the same time, and I can then relax and go into the studio or go on vacation. But there are only rolling completions. There is no time when everything is finished, and I can take time off and let go.

There is no substitute for a good schedule or calendar. I am sometimes overwhelmed with what I have agreed to do within a period of time. From far away, projects seem easy. I remind myself of that sign on car side-view mirrors: objects are closer than they appear. When they get closer, I realize there is not enough time to do all I have in my schedule, and I feel paralyzed with fear.

Fortunately, I have a left-brained friend who is always willing to help. She brilliantly breaks down my projects into bite-size pieces, and puts me on a schedule so that I can do a little bit every day. With this calendar, I usually finish

Success in any creative *medium* takes *time* and commitment; *encaustic* is *no* different.

ahead of schedule. If you are a predominantly right-brained person, as I am, try to enlist the help of a friend with some organizational and analytical skills.

Some days I declare an art Sabbath. I simply take the day off and go into the studio to play. My calendar helper allows for these studio days, and adds in several hours in my weekly schedule for studio time. It's good to come up with a plan that works for you, giving yourself enough time for the fun stuff as well as the-it's-got-to-be-done stuff. We have so many activities that revolve around supporting our work that we could simply do those and never actually get to do the work, so be sure you have enough creative time as well as time for marketing, shipping, and blogging.

In addition to your studio practice, you may be managing a job, kids, caring for an aging parent, and being in relationship. Balance is the key. Do the stuff you have to do, and give yourself a reward of studio time.

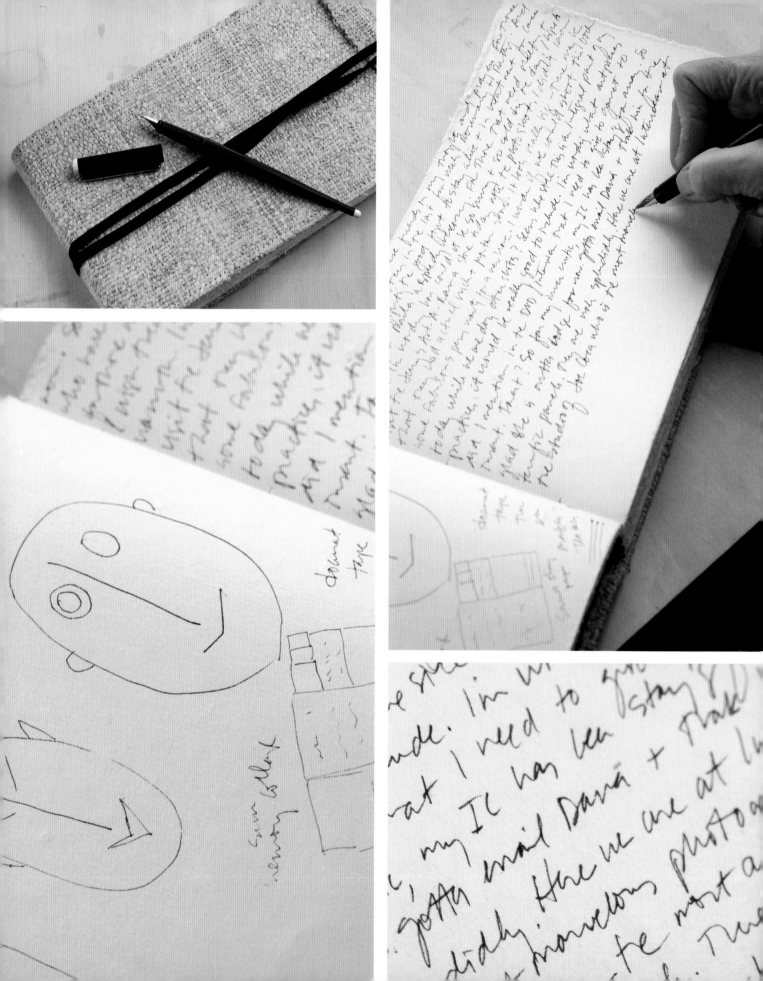

my journal *practice*

For many years I have practiced writing morning pages, inspired by the practice taught by Julia Cameron in *The Artist's Way*. The practice consists of writing three longhand pages of whatever comes to mind each morning, and I highly recommend it. In the photos at left, I'm writing with a lovely pen and journal, cherished birthday gifts from my partners at Wax Works, my teaching studio in California.

The very act of writing with a fountain pen on paper is pleasurable for me. It gets the thoughts out of my head and onto paper. Sometimes the writing takes me on a journey with branches, twists, and turns. It takes me away from linear thinking, frees me up, and shows me where I am in this moment. Sometimes it helps me solve problems. Sometimes I'm kvetching. These words are private and for me only. I hardly ever reread them; mostly I shred the journal pages right after writing and put the pieces into my artwork, for they are loaded with energy.

Every once in a while a revelation or something gorgeous will just fall onto the page, but my writing is mostly stream of consciousness and sometimes it's simply whining. Sometimes it takes the form of a letter that I want to send to a loved one. It is a wonderful way for me to check in and see if I might need to ease up on myself. Sometimes I'm angry or confused or perplexed, and it helps to write about it and just see it in words.

Ideas often come to me as I'm writing. Sometimes they'll be about trying out a new pen or paper; sometimes it's not the writing but the paper itself that inspires something new. That is precisely what happened in my True Grid series (page 128). And sometimes, instead of shredding, I'm folding written pages into origami sampan boats (page 150) and pinning a legion of boats up on the studio wall!

If you don't have a journal practice, give it a try. Write in longhand and see where the pages take you.

studio fundamentals

What separates the amateur from the professional artist? Often it's attention to the details of preparation, appropriate choice of materials, careful application, and finishing. Each visual art medium has its own idiosyncrasies and demands. This chapter includes some of my best tips for the basics of encaustic painting; they'll help you achieve results that will make you proud to share or sell your work.

safety

Safety is of utmost importance when working in encaustic. Without proper precautions, fumes, burns, pigments, and solvents can all present risks to your health. Many products are available that can make our studios safe working environments and allow us to work with confidence and focus on creativity and techniques. And remember, don't get too tired—take breaks and stay hydrated (encaustic is a very dehydrating activity, so drink a lot of water).

Fumes

Hot wax releases fumes that must be vented to prevent excessive inhalation. With adequate ventilation and proper working temperatures—keeping molten medium and paints at less than 220°F (104°C)—encaustic is safe and non-toxic. Be sure to have enough cross-ventilation in your studio. I keep my palette on a worktable that is 36" (91.5 cm) high, with a window right at my palette level. The fumes from the palette stay at palette level, and a box fan in the window vents the fumes to the outdoors. To test where the air current is moving the fumes, light a stick of incense and watch where the smoke travels; it should be going away from you and out of the studio.

Combustion

For both safety and aesthetic purposes, never overheat wax or encaustic medium. The flashpoint of beeswax is 490° to 525°F (254 to 274°C). With proper heating and melting tools and thermometers, you should not approach this danger point. Keep molten medium and paint at less than 220°F (104°C).

Burns

Keep a bucket of cool or room-temperature water in your studio; if you burn yourself, submerge your hand immediately in the bucket. Always be sure to get a burn under cool water immediately and keep it in cool water for fifteen to thirty minutes or apply a burn dressing. Have burn cream in the studio (I like a Chinese herbal burn cream called Ching Wan Hung). Wear gloves for protection from the palette, pigments, and the torch; I use nitrile gloves, but some artists use dishwashing gloves or gardening gloves. I also have heatproof terry-cloth gloves that I wear when moving paint receptacles or pouring medium or paint. Use common sense; if a burn is serious, seek medical attention immediately. Do not wait!

safety essentials *in the studio*

+ Adequate vents and exhaust fans

+ Bucket of water (cool or room temperature, not cold)

+ Fire extinguisher

+ Burn cream

+ Gloves and/or barrier cream with bar soap

+ Wet paper towels or rags within reach

+ Accurate thermometers for your palette and skillet

+ Closed-toe shoes

+ Apron to protect clothing

+ Hair ties for long hair

+ No flowing scarves, fringes, or ribbons

Pigments

Pigments, especially those made from heavy metals such as the cadmium and cobalt colors, should never be ingested or absorbed by the skin. While the danger is primarily in absorbing pigments through cut or broken skin, pigment left carelessly on the hands may be ingested. Wear gloves; if you don't like gloves, wear barrier cream and scratch bar soap under your fingernails to fill up the space so no pigment gets under your nails. Keep food out of the studio and never use utensils that you've used in the studio for food.

Solvents

Solvents can be toxic when heated. Do not use them with encaustic. I do use linseed oil as a release agent for stamps; it becomes dangerous when allowed to dry in a crumpled rag, which can combust, so follow the disposal method described on page 84. I recommend SoySolv II, a brand of soy-based cleanser, for cleaning hands and tools.

Common Sense

Common sense is your best friend in the studio. Keep your hair tied back and your clothing protected. Wear closed-toe shoes. If your eyes are sensitive and you typically wear contacts, wearing your glasses may feel more comfortable for you in the studio. Avoid wearing flowing scarves or ribbons that can get in the path of your torch. Store paper towels horizontally within reach at your worktable, but out of range of your torch; some of us can forget to turn off our open-flame torches and flambé the paper towels. If you use a heat gun, get a holster for it. Artists sometimes burn the inside of an arm by reaching over a heat gun or torch they have laid down on the tabletop. Always be conscious of the safety of others working with you in the studio—never point the torch in their direction.

substrates

Success with encaustic depends on the integrity of your surface. There are two principles to remember when choosing substrates (supports) on which to apply your encaustic medium and paint: the substrate must be both rigid and porous (see page 20). The material must also be heat resistant—it shouldn't melt under hot wax. Following these simple tips will ensure that your work is archival and will not be returned to you by your collector or gallery for repairs. Many things have these two essential components:

+ **Wood or plywood.** Birch plywood is an especially good choice because it is light in color. Untempered hardboard and the tropical plywood called lauan are other good choices. Masonite is not a recommended substrate for encaustic.

+ **Cradled panels.** Pre-made wood substrates with deep sides are readily available and will ensure that your work will not warp. Brace any panel sizes larger than 12" × 12" (30.5 × 30.5 cm). I've used Ampersand's Encausticbord brand cradled panels for the demonstrations in this book. This product is a substrate made and prepared for artists working in encaustic; it's ready for use and requires no treatment before sizing.

+ **Other options.** You can work with encaustic on bone, marble, stone, canvas or linen fabric glued to a substrate, bisque-fired ceramic, cast concrete, cast paper, paper pulp, or paper clay.

Some surfaces are rigid but not porous, such as metal. Others, such as stretched canvas, are porous but not rigid. Some materials, such as MDF plywood, have adhesives that should not be heated. Keep in mind that there are always exceptions to the rule. Very small pieces of metal or canvas might work (3" × 3" [7.5 × 7.5 cm] or smaller).

If you're just getting started, work with simple untreated wood panels or Encausticbord or other prepared substrates. After you've gained some experience and comfort with the medium,

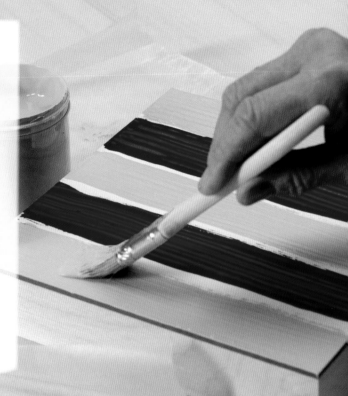

tip To create a ground in a color other than white, use tinted encaustic gesso (see Resources, page 156). Simply paint the colored gesso on the substrate with an inexpensive chip brush. Cover the entire surface and allow the gesso to dry. You are then ready to apply wax. Here, I'm painting colored encaustic gesso onto a cradled panel. You could lay down an entire painting before any medium is applied; this method gives you great control over your imagery.

you can branch out. With cradled panels such as Encausticbord, be sure to give the sides and back of your work some consideration before you begin to work to ensure professional presentation. There are several ways to treat the back and sides of a cradled panel; choose from my suggestions below.

Options for Cradled Panel Sides

Simply let the paint and wax drips flow over the sides of the panel and remain visible, as many artists like to do. This leaves the sides vulnerable to damage, so I recommend a floating frame to complete the piece with this technique. A floating frame leaves ¼" to ½" (6 to 13 mm) of space between the work and the frame, so that the sides of the work are protected from shock, trauma, or jarring in shipping.

Coat the sides of the panel with medium, fuse the sides by placing them briefly right on the palette, and give them a quick wipe-off with a paper towel. This seals the wood so that the moisture in the wood is preserved and will not dry out over time.

If you like a clean edge, apply blue painter's tape onto the sides of the work, as shown in the demonstration photos on page 42. In the demonstration photos, I use Ampersand

Encausticbord panels with a 1½" (3.8 cm) cradle; when I apply 2" (5 cm) wide blue painter's tape, I can simply and efficiently fold over the excess to protect the back of the work. When the painting is complete, I heat the tape a little bit with a heat gun (not an open-flame torch) and remove the tape—it releases with ease and won't chip into the face of your painting.

If you've kept the edges clean with blue painter's tape as described above, you can then stain the sides if you wish. Do this step after the work is complete and the tape is removed. Stains can contain solvents; do not use heat on the stain, as it will release toxins.

grounds

In art, the ground is the surface that you work on. In some cases the ground may be the substrate itself; more often, it's a first coating applied to it (such as gesso applied to canvas before painting). The surface, texture, and properties of the ground will affect your artwork. I like a white ground for encaustic work; it enhances the luminosity and depth of the encaustic medium and makes paint look gorgeous as the molecules of suspended pigment bounce off the white ground.

For a white ground, try one of these simple methods:

+ Use a **pre-gessoed cradled panel** such as the Encausticbord brand. This is an especially good solution for beginners. I use Encausticbord panels for most of the technique demonstrations in this book.

+ Use **titanium white encaustic paint** as the first layer on a sized substrate (see page 41 for more about sizing). White encaustic paint does have a tendency to bleed or spread or bubble, so it can be a tricky white ground; use when you're in the mood to experiment.

+ Adhere **white paper to wood** or to a wood panel (page 44). With this method, the heated wax may create dark areas as it soaks into the paper and renders the paper translucent. An initial layer of white gesso applied to the wood surface will prevent the wood from showing through.

+ Apply **white encaustic gesso** to a substrate before sizing. Encaustic gesso—a product that is quite different from acrylic gesso—provides an even first layer for the medium and paint to grasp. Unlike encaustic paint, gesso won't bleed or spread. You simply paint it on with a brush, let it dry, and voila! See Resources on page 156 for encaustic gesso sources.

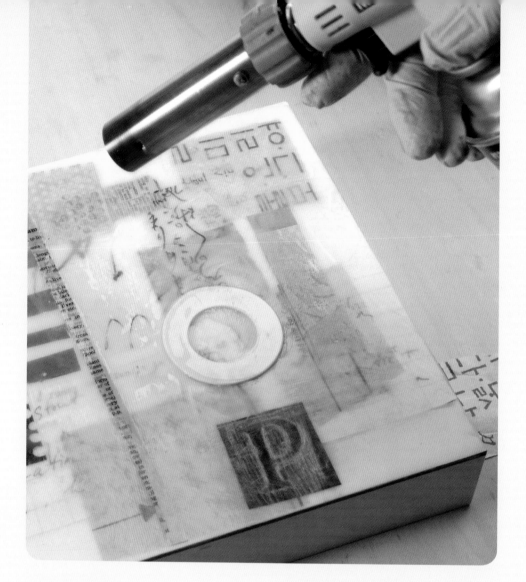

fusing

In the next set of instructions, you'll begin to see references to fusing. Every layer of an encaustic painting is fused to the layer beneath it with some heat source to bond the uppermost layer of encaustic paint or encaustic medium to the layer beneath. The act of fusing consists of heating the surface, usually with an open-flame torch, a heat gun, or an iron. Some artists use lightbulbs housed in an aluminum shade to fuse. Some artists I know put their work outside and let the New Mexico summer sun do the fusing.

I prefer fusing with an open-flame torch, and in particular, the Iwatani torch head. It's highly adjustable and can deliver a range of flames from very high all the way down to very gentle, so I have a lot of control. To see fusing in action, take a look at the DVD included with this book.

The accepted rule of encaustic work is to fuse after every layer of paint or medium so that it bonds to the layer beneath. Follow this rule in most cases (I've noted a few exceptions on page 41). Beginners often wonder how long they should fuse, or how they'll know when the fusing is complete. After applying the molten encaustic paint or medium to the surface, it will appear matte, with visible brush marks. As you heat the surface with your chosen fusing tool— heat gun, torch, or iron—the surface changes from matte to shiny. When the surface is shiny, fusing is complete. The surface will return to a matte appearance as it cools, but it will be smooth, without visible brushstrokes.

There are exceptions to the rule of fusing after every layer of paint or medium. Fusing after each layer can make for a very smooth surface. If you want more texture, you can omit fusing every layer, and instead fuse every five

to ten layers. Such surfaces are usually more vulnerable to chipping off, because every layer is not bonded to the layer beneath. Another exception is when one is using a hot wax stylus pen to draw on top of the wax. The paint is being applied right at 200°F (93°C), so it does not need to be fused. Some collage projects where materials are dipped in wax, such as the Mom's Recipes Collage project on page 126, do not need additional fusing.

sizing a panel or substrate

To size a panel is to seal or otherwise protect a surface before painting. Applying the first layer or layers of beeswax or medium to a panel or substrate is my standard method of sizing. If you were to apply encaustic paint directly onto wood, the pigment would stain the wood irreversibly. By sizing the panel with a first layer of either beeswax or medium, the substrate is protected from staining. If your work isn't satisfactory, you then have the option of removing the paint and reusing the substrate.

If your substrate is larger than about 18" × 18" (45.5 × 45.5 cm), paint your first layer with pure beeswax. This is economical—encaustic medium is often as much as four times as expensive as pure beeswax. Fuse the wax, then add a layer or two of medium, a blend of beeswax and damar resin.

If you're using a cradled panel, heat it on a palette (with the back edges, not the front of the panel, on the palette) before you size it; the beeswax or encaustic medium will soak into the wood faster and have fewer air bubbles. When I size Encausticbords that are heated first, they are smooth after two applications of medium. When I size them at room temperature, it takes four applications to achieve a smooth surface.

After heating the panel for a few minutes, apply a layer of beeswax or medium with a wide brush.

Fuse this layer and let cool. For an even smoother surface, apply a second layer and fuse.

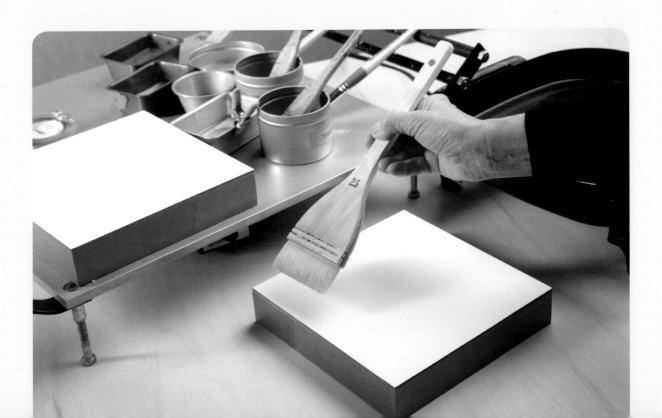

how to tape a cradled panel

MATERIALS + TOOLS

☐ Cradled panel

☐ 2" (5 cm) wide blue painter's tape

☐ X-Acto knife or box cutter

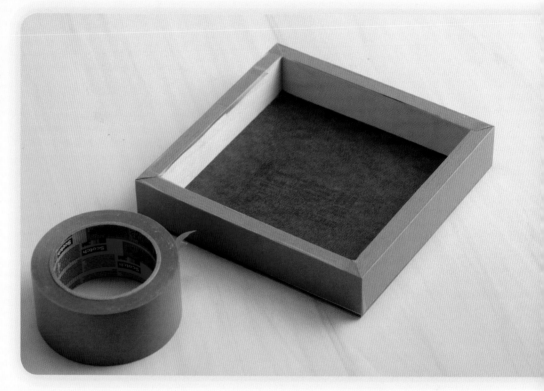

Regardless of the treatment you choose for the sides of the panel, protect the narrow back edge of the panel sides with blue painter's tape before you begin to work. Keeping the back of the work clean is a matter of professionalism. If your work goes to the home of a collector, you don't want paint that dripped onto the back of your painting discoloring her walls. Your gallerist may take your work on approval into some collector's home and hang it on her beautiful palomino-colored Venetian plaster walls. If you leave a mark of encaustic paint on her wall, that collector probably won't buy your work, and you and your gallerist won't be invited back.

steps

1 | The cradled panel shown has 1½" (3.8 cm) deep sides and ½" (1.3 cm) wide back edges; 2" (5 cm) wide blue painter's tape will cover the sides and back edges perfectly. To apply the tape, it's easiest to start the tape in the middle of a side.

2 | Continue to **apply** tape around the sides.

3 | In **fig. 3,** three of the four sides are taped.

4 | On the fourth side, **overlap** the end of the tape slightly over the starting point. **Tear** the end of the tape or cut it with an X-Acto knife.

5 | Begin to **press** the remaining tape down on the back edges of the panel.

6 | **Fold** the corners of the tape for a neat edge. All sides and back edges are now protected.

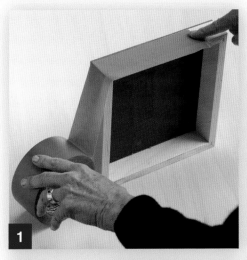

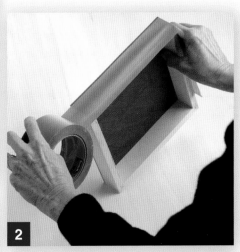

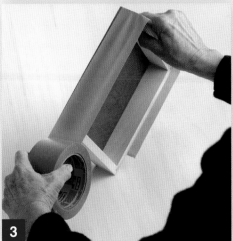

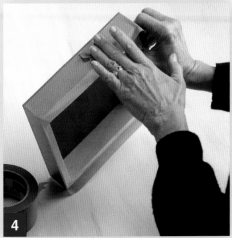

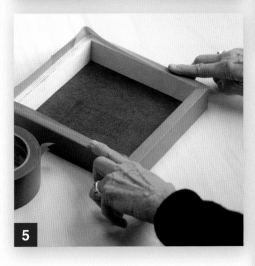

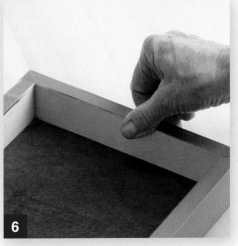

how to adhere paper to a substrate

MATERIALS + TOOLS

☐ Plywood or cradled panel

☐ X-Acto knife or box cutter

☐ Self-healing cutting mat

☐ Paper slightly larger than the substrate

☐ Waxed paper

☐ PVA glue or acrylic gel medium

☐ Paintbrush

☐ Brayer or shim

☐ Stone or other weight

☐ *Optional:* White encaustic gesso or white acrylic paint

Adhering paper to a substrate is one way to create a white, colored, or patterned ground for encaustic work. I like to use Rives BFK, a high-quality paper made for printmaking; you can use this or other plain white paper or printed paper, as long as it has no shiny coating. You can also adhere a drawing, watercolor, matte photograph, stamped image, monotype, intaglio print . . . the choices are infinite. A graphite or chalk drawing may smear, however.

steps

1 | If using plywood, you may wish to **paint** it with white acrylic paint or gesso. This is optional, but will prevent wood from showing through when the wax makes the paper transparent. Allow the paint or gesso to dry. Although normally acrylic products should not be used in encaustic, in this case the layer of paper between board and wax makes it an acceptable and inexpensive option. Using the knife or box cutter and self-healing cutting mat, cut your selected paper to a size about ½" (1.3 cm) larger in all directions than the support. With a sheet of waxed paper protecting your work surface, brush a thin coat of gel medium or PVA glue to the support.

2 | **Brush** a thin coat of gel medium or PVA glue to the back of the paper.

3 | When the glue is tacky (this should take only a minute or so) **place** the substrate face down on the center of the wrong side of the paper.

4 | **Flip** the substrate over (with paper adhered to face) and cover with waxed paper. Use a

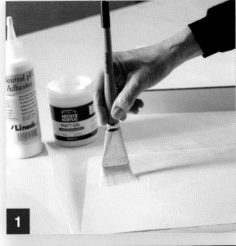
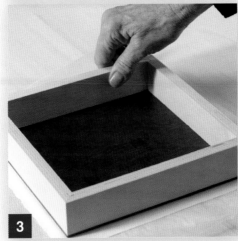

brayer, cardboard shim, or old credit card to remove air bubbles from the surface. Weight the substrate and allow to dry overnight.

5 | When dry, **trim** away the excess paper with the box cutter or X-Acto knife.

6 | Your panel or other support now has an adhered paper surface and is ready to be sized, as described on page 41.

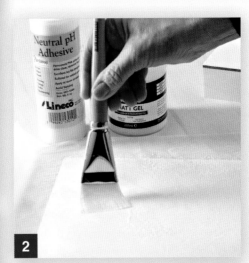
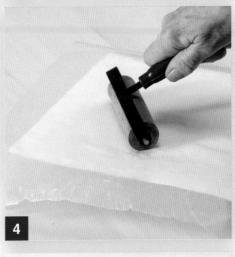
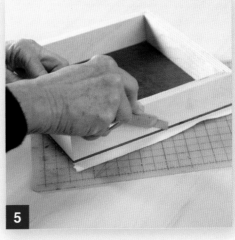

how to create a textured ground

MATERIALS + TOOLS

□ Nitrile gloves

□ Plywood, cradled panel, or other substrate

□ Joint compound or drywall mud

□ Trowels, notched and unnotched

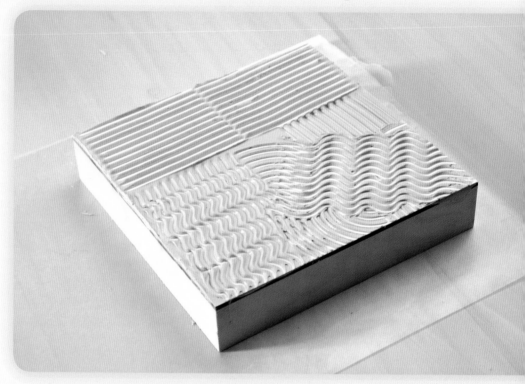

Create a textured ground by applying drywall mud or joint compound to a panel or plywood. Trowel it on in a fairly thin layer, let it dry, and keep applying it until you achieve the desired texture, then allow to dry before sizing. I call this process *mudding* in the enclosed DVD.

steps

1 | Wearing gloves, **apply** the joint compound or drywall mud with the unnotched trowel over the entire panel.

2 | **Run** a notched trowel across the panel, making grooves into surface.

3 | **Continue** to make pattern in the surface with the notched trowel until you are satisfied. Let dry.

4 | *Optional:* **Paint** directly on the textured surface inside the grooves you've made with watercolor paint, India ink, or other non-acrylic paint.

5 | Allow the painted or unpainted panel to dry before sizing.

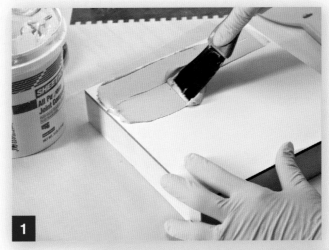

1

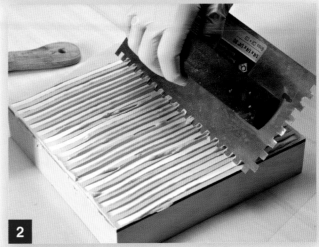

2

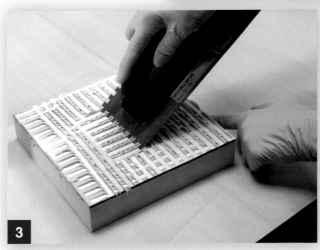

3

how to apply paint to a sized surface

MATERIALS + TOOLS

- □ Sized cradled panel or other substrate
- □ Palette or electric skillet
- □ Encaustic paint in various colors
- □ Brushes
- □ Heat gun or torch

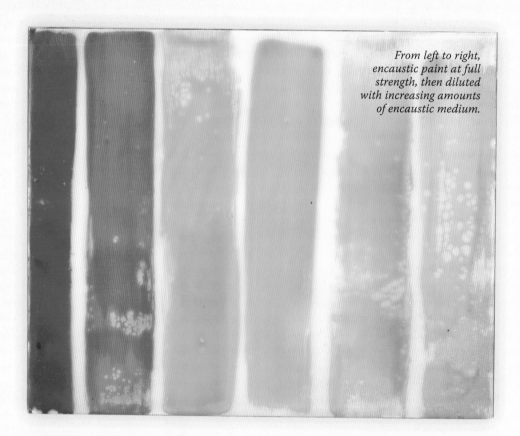

From left to right, encaustic paint at full strength, then diluted with increasing amounts of encaustic medium.

Encaustic paint, a mixture of beeswax, damar resin, and pigment in the proper proportions, is the most saturated and gorgeous of all paints. Melt encaustic paint directly on your palette, or put some into a metal tin on your palette and then apply to your panel with a brush. Use the paint at full strength or thin it down with medium; the photograph above shows alizarin orange (R&F brand) in a range from full strength to very diluted with encaustic medium. I prefer to paint many layers of diluted paint to fewer layers of full-strength paint.

steps

1 | **Brush** encaustic paint onto the sized panel in any manner—I'm using wispy "X" strokes and straight lines in **fig.1.**

2 | After application, **fuse** the layer of paint with a heat gun or torch. For successful and archival encaustic work, the general rule is to fuse with heat after each layer. It takes some practice to get used to the effect of heat on the paint and avoid creating hot spots from holding the torch or gun too long in any one area. Fuse in a rhythmic fashion, from one side to the next, covering all the areas on your panel, and not staying long in any one place. If you hold your torch too long in any one area, you can create a hot spot—notice in **fig. 2** where the white circle has formed and melted the green paint away. Try to avoid hot spots by keeping the heat gun or torch moving smoothly and not too close to the surface.

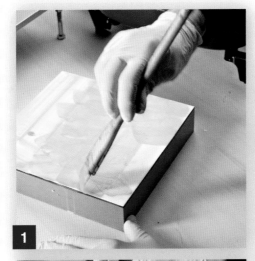
1

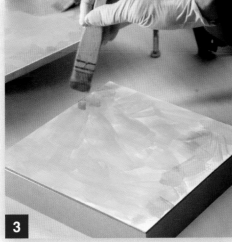
3

3 | **Add** another layer of encaustic paint.

4 | **Fuse** this layer with your heat gun or torch.

5 | Continue **painting** and **fusing** in this manner. The more layers of paint you apply, the richer the color will become.

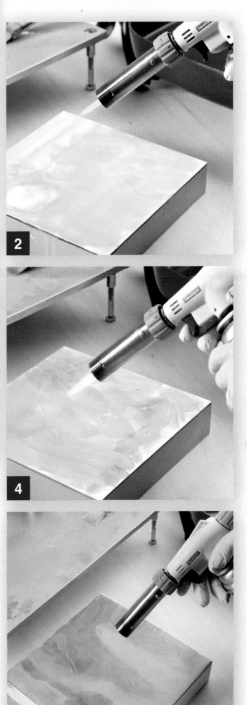
2

4

5

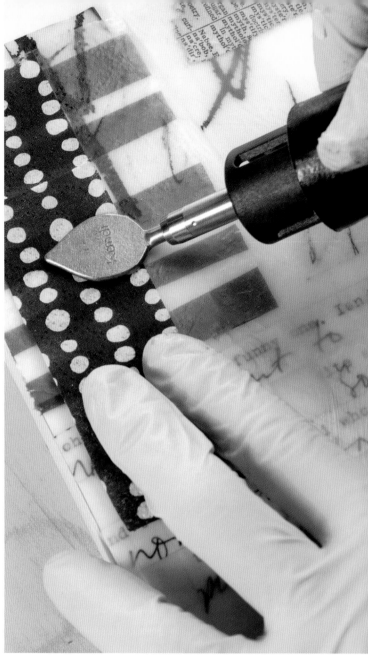
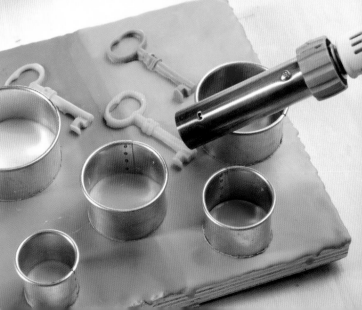

mixed-media techniques

You've learned the fundamentals of encaustic practice—preparing a substrate, sizing, applying an appropriate ground, and fusing after each layer of encaustic medium or paint— and you're ready to explore mixed-media techniques. In the following pages, I demonstrate my favorite methods of working with collage, pigment, cast shapes, lines and edges, and more. Work through the techniques in order or mix them up. None are difficult, but all will reward your practice and experimentation. For each technique, begin with the basic encaustic tool kit described on page 10. The instructions list additional materials specific to each technique. And don't forget to view the DVD included with this book to see me demonstrate many of these techniques.

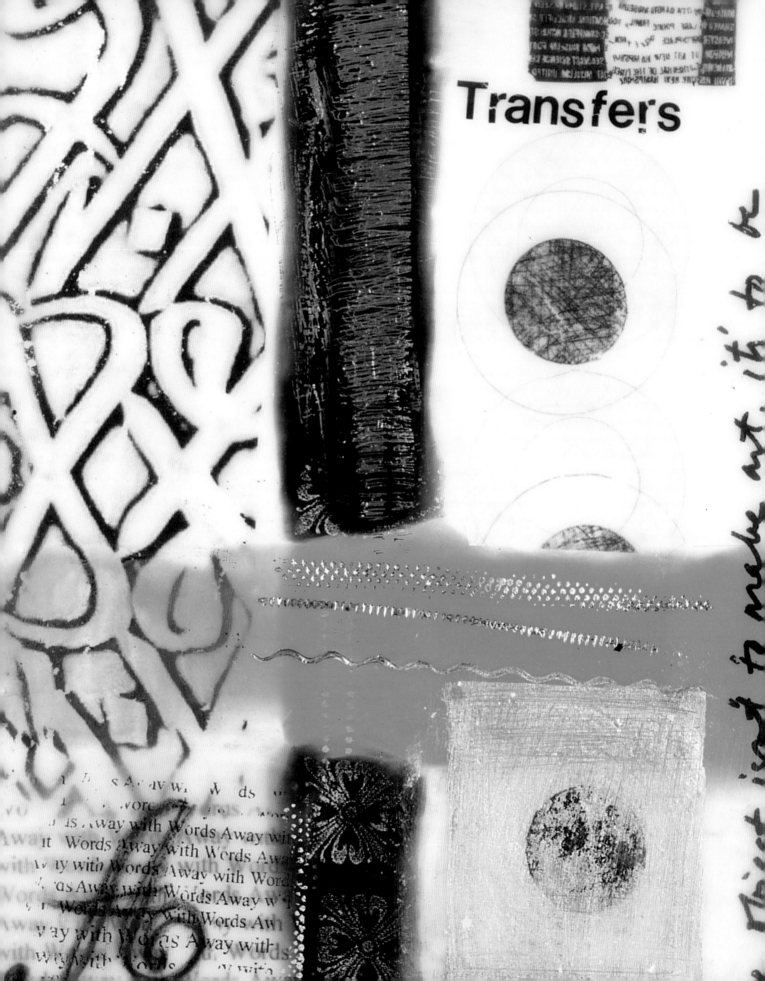

Transfers

transfers

Drawn or printed images or materials
such as metallic foil can be transferred
directly onto the encaustic wax surface
with a number of easy methods and
without solvents. The wax has an
adhesive quality, allowing images to
be transferred by firmly rubbing with
a burnishing tool. Transfers work
best on smooth wax surfaces. When
working with photocopied or printed
images, be aware that some inks and
toners are not archival. (I recommend
wilhelm-research.com as a resource for
information on permanence of various
substances.) If you sell mixed-media
art that you've made with non-archival
materials, be sure to tell the collector,
curator, or gallery.

toner-based *images*

MATERIALS + TOOLS

- ☐ Basic encaustic tool kit (page 10)
- ☐ Cradled panel or other substrate prepared with a smooth encaustic surface
- ☐ Toner-based print or photocopy image for transfer
- ☐ Scissors
- ☐ Small container of water
- ☐ Burnishing tool

With this traditional method, you must transfer the image within thirty minutes after the last fusing of your surface, which should be warm but not hot. The transfer will be more successful if the surface of the wax is smooth. Use a photocopy that has been made on a toner-based photocopier or printer. Laser printers are toner-based, but most inkjet copies will not work.

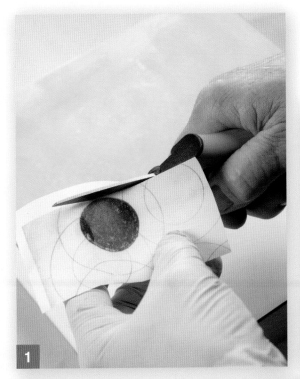

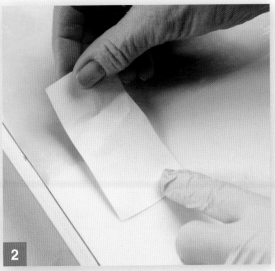

steps

1 | Closely **trim** the image with scissors.

2 | **Place** the image face down on the wax and **cover** the image with waxed paper.

3 | Using a burnishing tool, **rub** the image using an overlapping circular motion. Remove the waxed paper.

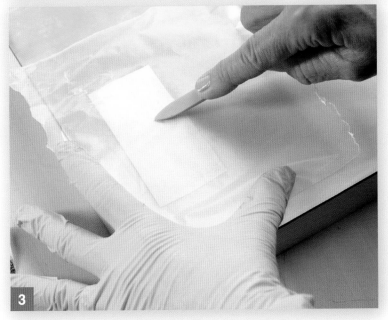

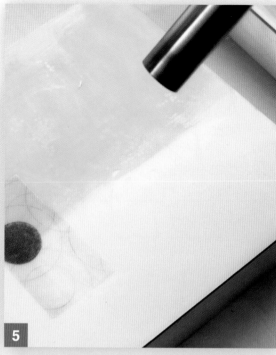

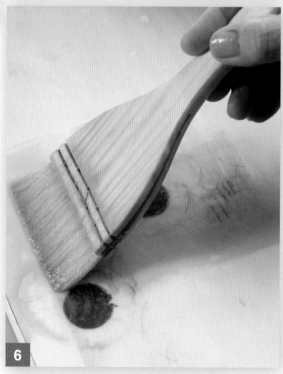

4 | Using your finger, apply a little water to the back of the photocopy. Replace the waxed paper and burnish again. The image will begin to appear through the paper. Remove the waxed paper and begin to **gently rub and roll** the photocopy paper off with your finger, applying more water if necessary, leaving only the transferred image on the wax. Some paper fibers will remain on the surface.

5 | Lightly fuse the image. To lightly fuse, I recommend using a low flame with the Iwatani torch head. **Very gently lick** the surface of the wax with the flame or heat. As you fuse, any remaining paper fibers will become transparent and disappear as the wax rises up and encapsulates them. The toner will darken at the same time. If you continue, the toner will break up, distorting the image—an effect you may or may not want. If you're using a heat gun, fuse briefly with the gun a little farther away from the surface than usual, and use a low setting if available. Practice will help you to determine how much fusing to do.

6 | After fusing, allow the surface to cool. **Apply** a thin coat of transparent encaustic paint or encaustic medium to protect the image.

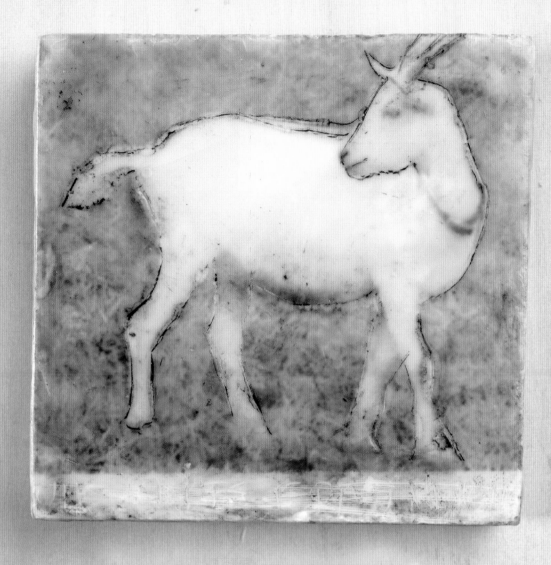

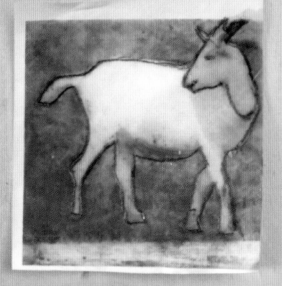

work process: whidbey island goat

Here's an example of my work process. For this piece, I took a photograph of a beautiful creature at the Whidbey Island Goat Rescue in Washington state and printed it out on my inkjet printer. I then painted the substrate with encaustic gesso to achieve a white ground. I adhered the photo of the goat to the substrate with acrylic gel medium. I heated the panel and poured medium over the surface. After the panel was cool I scratched a depression in the wax around the shape of the body of the goat and filled it with pigment stick, delineating the figure. I allowed some of the turquoise green pigment stick to remain on some of the panel to color and stain the surface a bit.

parchment paper *transfer*

MATERIALS + TOOLS

☐ Basic encaustic tool kit (page 10)

☐ Cradled panel or other substrate prepared with a smooth encaustic surface

☐ Toner-based image on parchment paper

☐ Burnishing tool

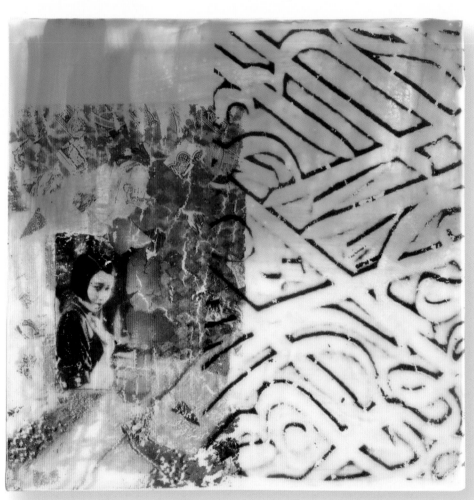

Parchment paper, also called professional baker's paper, is available through bakeries and can be run through toner-based (laser) printers and copiers. You can use each side of the paper twice before discarding as long as you don't cut out the individual images from the sheet. Parchment paper won't work with all printers and copiers, so experiment.

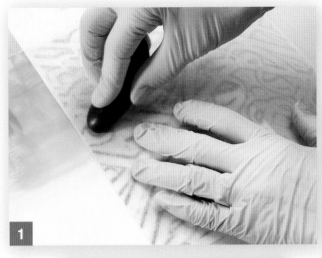

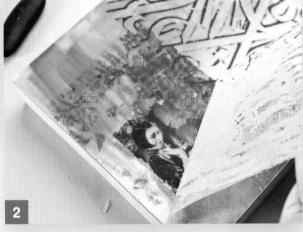

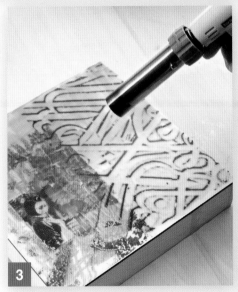

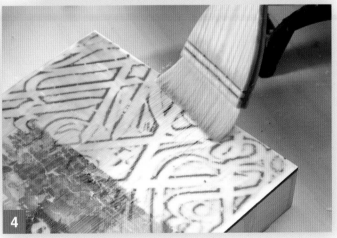

steps

1 | **Make** a toner-based photocopy on parchment paper of the image or images you want to transfer. You can also print in color with a toner-based printer and transfer color imagery. (If necessary, tape the parchment paper to a base sheet of plain copy paper so it will run successfully through the printer. On my printer, I run a single sheet of parchment using the manual feed. After printing an image, run a plain sheet of paper through the printer to clean it before moving on to the next sheet of parchment.) **Place** the parchment paper, image side down, on your smooth encaustic surface. **Rub** the image with a burnishing tool to transfer the image to the surface.

2 | **Repeat** with a second image if desired. I added a color image.

3 | **Lightly fuse** the image so the toner will become encapsulated in the wax.

4 | After fusing, allow the surface to cool. **Apply** a thin coat of transparent encaustic paint or encaustic medium to protect the image.

rub-on *type*

MATERIALS + TOOLS

□ Basic encaustic tool kit (page 10)

□ Cradled panel or other substrate with a smooth encaustic surface

□ Sheets of Letraset or other rub-on type

□ Scissors or X-Acto knife

□ Burnishing tool

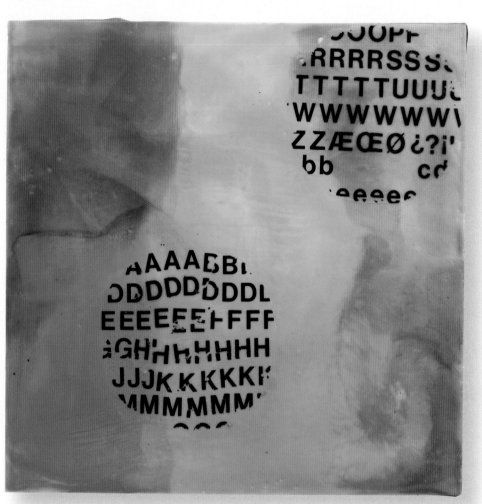

Sheets of rub-on type, such as Letraset brand, were once an essential tool for graphic artists, but digital design has made them obsolete for many uses. They're still available, however, and they're perfect for encaustic work, whether you're adding words to your art or using letters to form patterns.

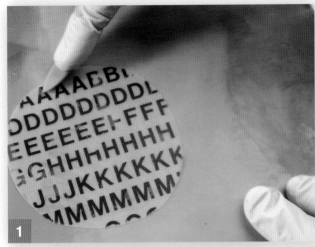

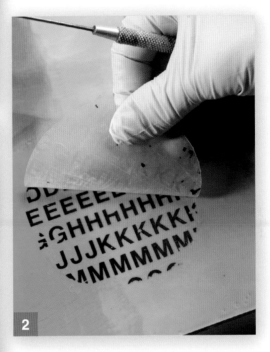

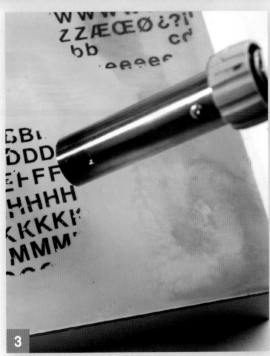

steps

1 Using scissors or an X-Acto knife, **cut out Letraset or other rub-on type** as desired. In this demonstration, I've cut a circle shape of the letters. Place the type, letter side down, on your smooth encaustic surface (prepared with encaustic medium or encaustic paint). With a burnishing tool, rub the plastic paper carrier of the rub-on type sheet until you see that the letter or letters have left the plastic carrier sheet and transferred onto the wax.

2 **Peel back** the plastic carrier sheet. Repeat as needed with additional letters, or cut out shapes with letters.

3 **Fuse.** If you heat the surface too long, the letters may float and swim around on the wax, or break up a little bit. Unpredictable, but fun!

4 You may put a coat of **encaustic medium** on top if you choose (or if you plan to add additional layers), but it is not necessary.

drawn *images*

- ☐ Basic encaustic tool kit (page 10)
- ☐ Cradled panel or other substrate prepared with a smooth encaustic surface
- ☐ Image drawn on paper with pencil, graphite, chalk pastels, charcoal, or carbon-based pencil
- ☐ Waxed paper
- ☐ Burnishing tool

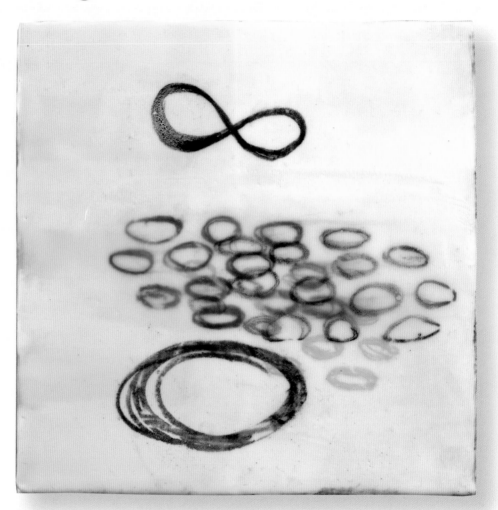

If you keep a sketchbook and draw frequently—a practice I recommend—you'll have a supply of images for the technique of transferring drawn images onto an encaustic surface. Try this easy method with images made with pencil, graphite, chalk pastels, charcoal, or a carbon-based pencil such as a Primo Elite Grande.

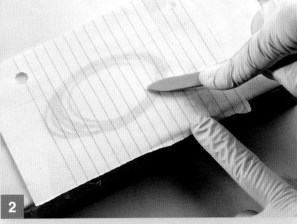

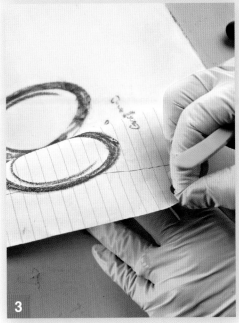

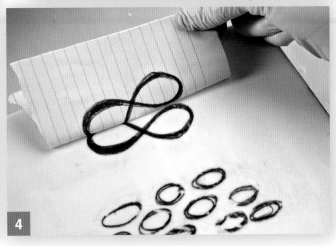

steps

1 | If you don't already have a **drawing** to work with, create one on any kind of paper with any of the drawing media listed. In **fig. 1,** I'm using a 9B graphite pencil.

2 | Put the drawing face down on an encaustic surface that has been fused within the last thirty minutes. **Rub** with a burnishing tool.

3 | **Peel back** the paper to reveal the transferred image. Fuse gently. Wait for the wax to cool down before you paint medium over this. Sometimes the graphite, charcoal, or other drawing medium will smear if you brush medium over it while the surface is warm.

4 | If desired, continue with other images.

5 | **Fuse.** Allow to cool. Apply medium, let dry, and continue to layer imagery, fuse, and brush medium as you wish. I added a final transfer of chalk pastels in my piece.

wax-free and carbon *papers*

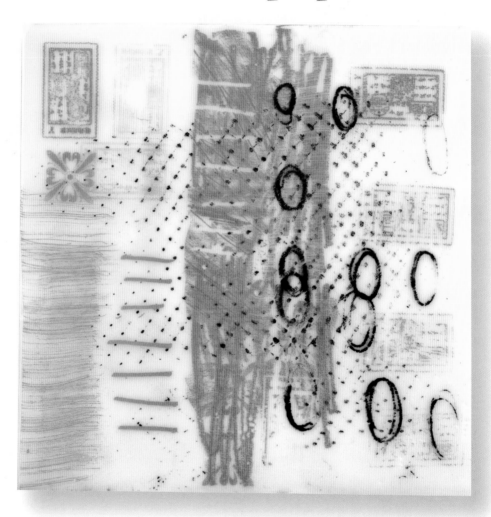

I use the Saral brand of wax-free transfer paper; art supply stores sell Saral in 12½" (31.5 cm) wide rolls in several colors. Carbon paper is available at office supply and stationery stores. Use any kind of mark-making tool on the back of the Saral or carbon paper to transfer an image to an encaustic surface.

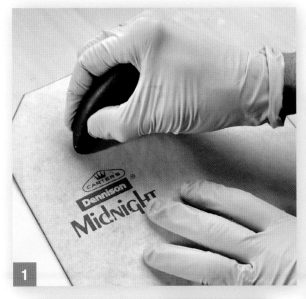

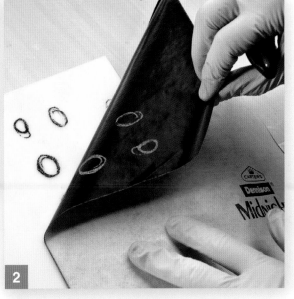

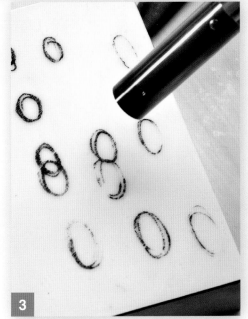

steps

1 | For my demonstration piece, I began with carbon paper for the first layer, followed by Saral paper. Lay carbon paper face down on the smooth encaustic surface. It can be cool or warm, but should not be hot. **Draw or make marks** on the back of the carbon paper; in **fig. 1,** I'm using a smooth stone. Experiment with making marks with other implements.

2 | **Peel back** the carbon paper to reveal your drawing.

3 | **Lick the surface** of the wax very lightly with a low flame from your torch or low setting on your heat gun. If you apply too much heat, the lines will disperse or break up in the wax. **Apply a thin coat** of encaustic medium to protect the image.

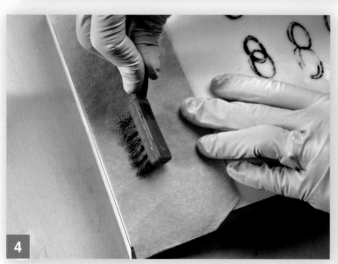

4

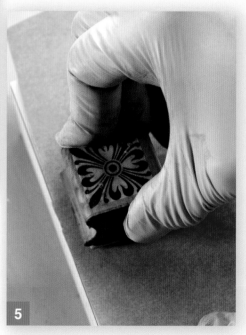

5

4 | My next layer uses red Saral wax-free transfer paper as the transfer medium. The process is similar to that for carbon paper, above. **Lay** the Saral paper on the encaustic surface with the brighter side down. I began with a burnishing tool to make lines, then **use a wire brush** to add delicate feathery marks.

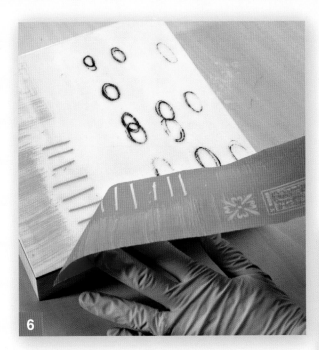

5 | Next, I **pressed a stamp** into the Saral paper. Either the encaustic surface or the stamp should be a little warm; place the stamp on a warm palette for a minute or two.

6 | **Peel back** the Saral paper to reveal your marks.

7 | **Fuse.**

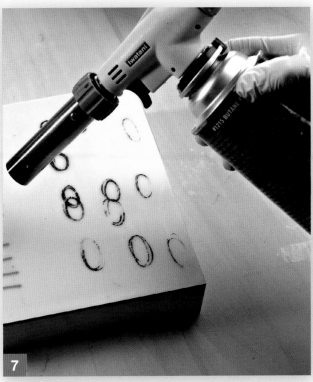

8 | For the last layer on the demonstration piece, I **added overall texture** by putting down carbon paper, then **rolling a brayer** over mesh-plastic vegetable bag material to transfer a pattern. I then took off the paper and fused the final layer.

joss paper, metal leaf, and *foil*

MATERIALS + TOOLS

- ☐ Basic encaustic tool kit (page 10)
- ☐ Cradled panel or other substrate with a smooth encaustic surface
- ☐ Sheets of metallic foil in desired colors
- ☐ Sheets of metal leaf (gold, silver, copper)
- ☐ For metal leaf: clean cotton balls or soft unused brush
- ☐ Silver-colored joss papers
- ☐ Cup of water
- ☐ Scissors
- ☐ Waxed paper
- ☐ Mark-making tools
- ☐ Roller tools with metal faces
- ☐ Burnishing tool
- ☐ Bookbinder's awl

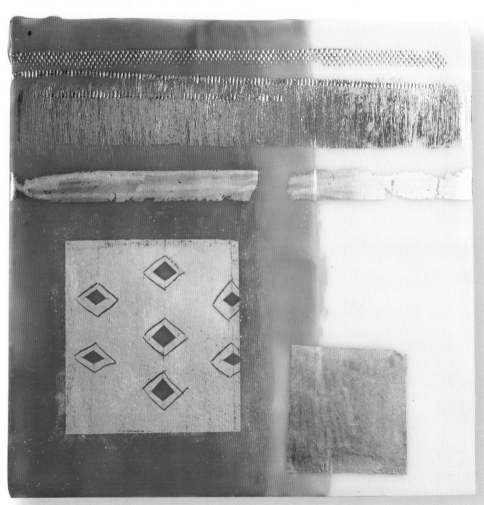

Metallic foils come in many colors and will transfer with heat. *True metal leaf* is popular with mixed-media artists, but it can be costly. Use it sparingly to create a rich, beautiful element on your encaustic surface. I use what's called patent leaf; it has a thin backing sheet and is easy to cut in shapes.

Joss paper is a foil paper with printed images used ceremonially in China; it's readily available in Asian markets and from some mixed-media art supply retailers. Note that the gold color is an orange wash that will come off in a transfer process; use silver joss paper for transfers, and gold in collage.

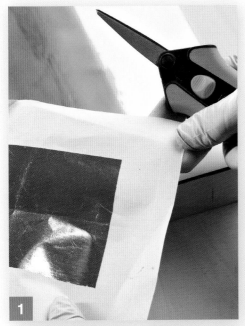

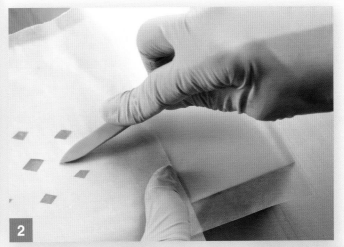

1

2

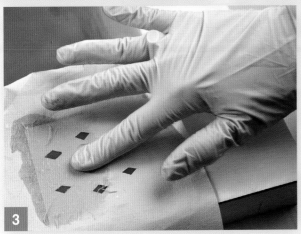

3

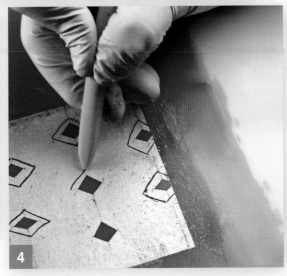

4

steps
joss paper

1 | This demonstration piece begins with a transfer of joss paper. I like to start by folding a square of paper (metallic sides together) and cutting diamond shapes with scissors.

2 | **Lay** the joss paper metallic side down on an encaustic surface that has been fused within the last thirty minutes. If you have cut into the joss paper as I did, put waxed paper on the Joss before you burnish to protect your tool and avoid disturbing the joss paper. **Burnish** the entire area to be transferred.

3 | **Remove** the waxed paper. **Rub** water on the back of the paper with your finger and rub the excess paper off to reveal the metallic sheen.

4 | If you wish, **draw** on the joss or make reductive marks, lightly scratching through the metal, revealing the color of the wax beneath. To maintain a shiny metallic surface, do not apply medium over the joss paper.

metal leaf

5 | To apply metal leaf, begin with an encaustic surface that has been fused within the last thirty minutes. Using scissors or a craft knife, **cut** the metal leaf into the shape you desire.

6 | Place the metal leaf face down on the encaustic surface and **rub** with a burnishing tool.

7 | **Remove** the protective backing from the metal leaf.

8 | **Gently rub** the back of the leaf with a clean cotton ball or soft "virgin" brush. To maintain luster, do not apply medium. You can fuse, but it is not necessary. It's best to use metal leaf as your final layer.

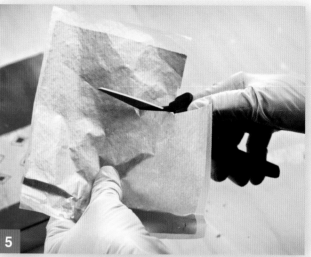

5

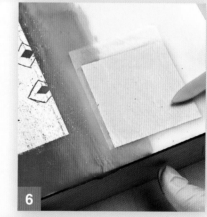

6

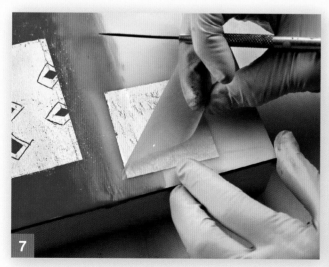

7

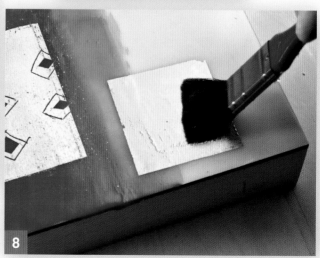

8

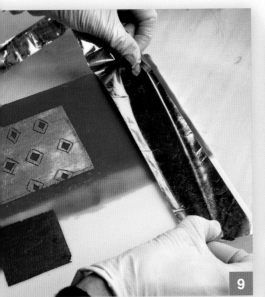

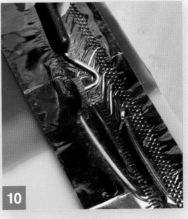

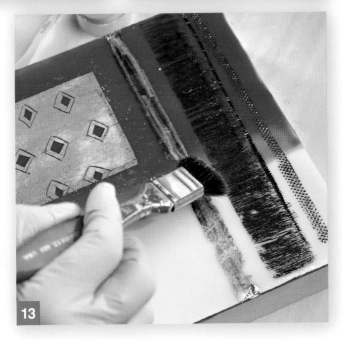

metallic foil

9 | I'm using metallic foil sheets on the next area on this demonstration piece. **Warm** the encaustic surface. Place foil with the metallic side facing you (this is not intuitive; it's the opposite of what you think should work) on the warm surface.

10 | Use any mark-making tool, such as a pen, a stamp, or a tool with a blunt end, to **transfer** foil designs onto the surface.

11 | If desired, add texture by **running** a wire brush across the surface.

12 | **Peel back** the foil tape to reveal the transferred metallic foil.

13 | To complete this demonstration, I applied a thin strip of 22-karat **gold leaf.** Most leaf comes with a very thin protective tissue paper to protect it; after removing the tissue, I gently burnished the leaf right onto the surface with my virgin brush.

transfers

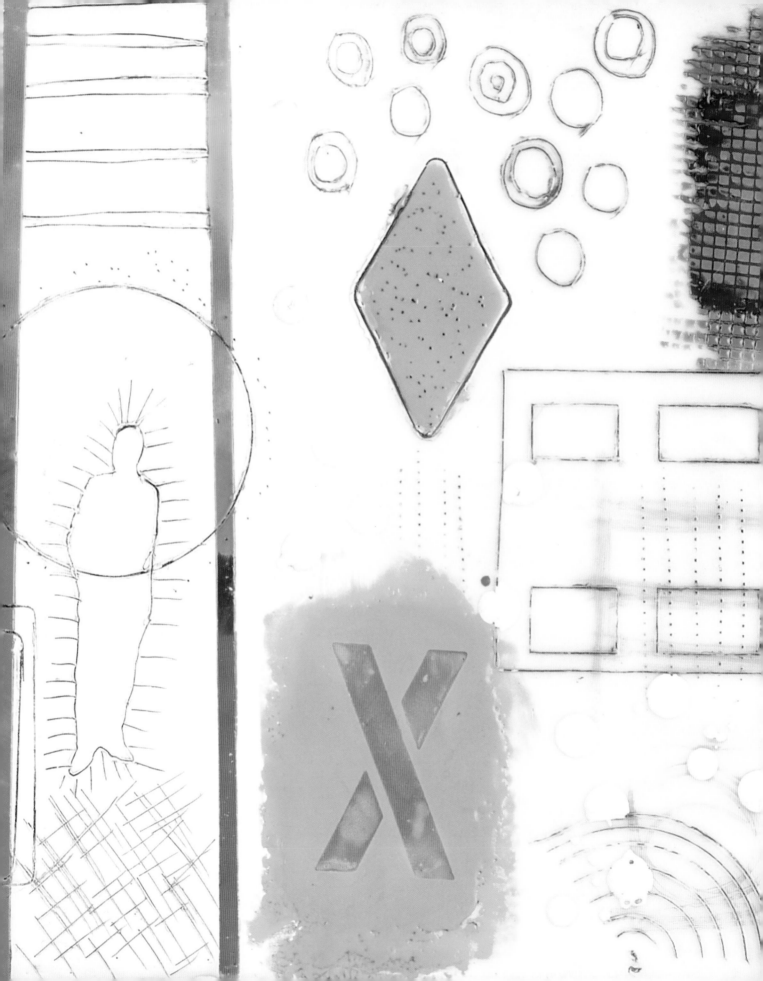

lines + edges

This section includes techniques for working on top of and below the surface of an encaustic painting to create images with lines and edges. You already have tools in your studio that will make wonderful marks on a surface, and I encourage you to look for new mark-making implements wherever you go—I like yard sales and thrift stores. Techniques include making incisions beneath the surface and filling them with another color, stamping into the surface to make an impression in the wax, and using stencils to make lines and shapes.

painter's tape, incise and fill, and *wax stylus pen*

MATERIALS + TOOLS

☐ Basic encaustic tool kit (page 10)

☐ Cradled panel, drywall surface, or other substrate painted with encaustic gesso

☐ Blue painter's tape (I recommend #2080 for delicate surfaces)

☐ Burnishing tool

☐ Linoleum cutter, pottery scraper, razor blade, notched metal trowel, or other hand tool that will allow you to cut grooves into the wax

☐ Hot wax stylus pen

This demonstration offers several techniques for creating lines and edges, whether straight or in patterns. First, I use blue painter's tape to create hard-edged lines that are above, not flush with, the encaustic surface. My incise-and-fill technique involves making valleys or troughs in a thick encaustic surface, then filling them with medium or a contrasting color of paint. Scraping the surface reveals a flat plane with an embedded line or design.

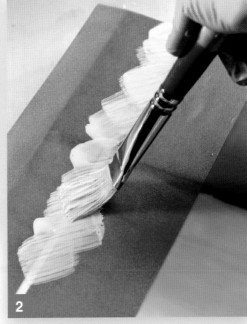

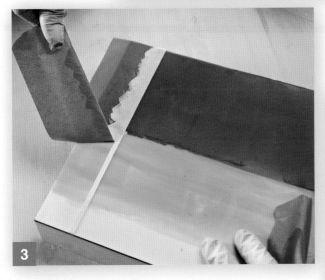

steps
blue painter's tape

1 | **Lay down** blue painter's tape across the surface of your work and firmly rub the tape in place with your fingers. In **fig. 1,** I've applied two pieces, creating a thin line between the pieces of tape.

2 | With a brush and encaustic paint, **paint across and over** the tape to fill in the line completely. Lightly fuse.

3 | **Peel away** the pieces of blue tape to reveal a nice clean line.

4 | Continue this process as desired, painting the line different colors, some translucent, some opaque.

incise and fill

5 | **Paint** ten to twenty layers of the same color of encaustic paint on your substrate, fusing between each layer. Be sure the final surface is very warm, or give it a good fuse before you begin to cut grooves in the surface.

6 | Take a linoleum cutter with a U- or V-shaped groove, and begin to **incise a groove** in the wax surface. Dig down just a few layers or go all the way to the board if you like. You can scribe this as a straight line, a curvy line, or even use a stencil to guide you. You'll be lifting a burr of wax out of the groove as you go. Save this burr; you can melt down and reconstitute paint that you've removed from the surface.

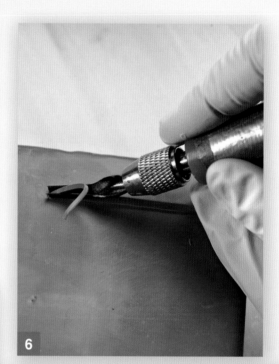

6

5

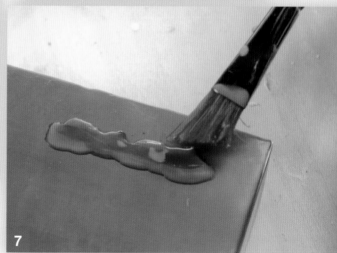

7

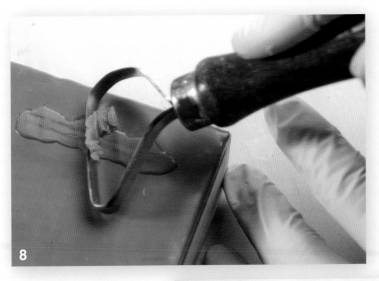

7 | **Fill the recession** with a contrasting color of paint, filling up and over the top surface. You can give the filled grove a very light fuse with a gentle flame. Look for the wax to just turn shiny for an instant. *Note:* Some artists don't fuse filled areas until after scraping excess paint, as it's easier to scrape unfused layers. Try both and see what works best for you.

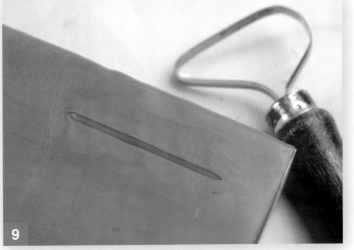

8 | Use an appropriate tool to **gently remove** the layers of the wax above the surface. You'll begin to see the incised line reveal itself.

9 | After fully removing the excess surface paint, you have a beautiful smooth line or shape flush to the surface. See page 79 for more tips on this process.

hot wax stylus pen or encaustic pen tool

10 | With the pen on and heated up, **press** the nib into an unmelted, solid brick of encaustic paint. Through capillary action, the paint gets drawn up into the nib.

11 | **Dispense the paint** right onto your surface, making dots or lines as desired. Reload the pen with paint and repeat. There's no need to fuse, as the pen delivers the paint at a constant 200°F (93°C).

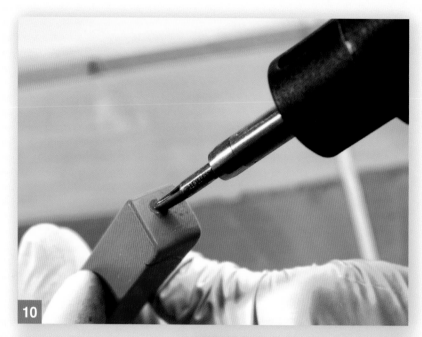

10

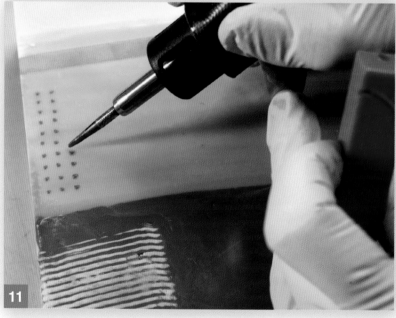

11

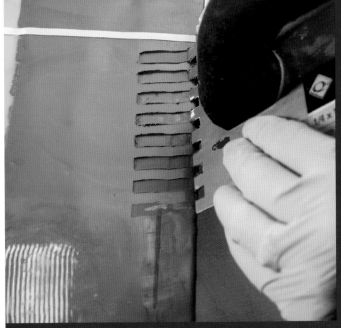

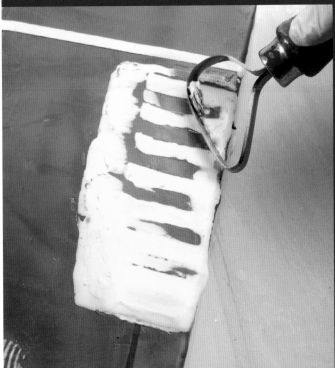

incise-and-fill success tips

The incise-and-fill process takes patience and practice but is eventually very rewarding; it's satisfying in its tactile nature, has a dimensional and layered quality, and gives you endless artistic options. Remember: If your surface is warm, your tool should be cold. If both surface and tool are cold, it will be hard to scrape off the excess wax. If both tool and surface are warm or hot, you'll have no control. So much of encaustic is finding the sweet spot—what I call the Goldilocks moment, not too much or too little but just right— and that comes with practice.

Your scraping tool can get very gummy after a few pulls and can redeposit the gummy wax back on the surface. To prevent this, have multiple tools that you can use in succession until the job is done. Then clean them on your hot palette and allow them to cool for the next use. Razor blades are an economical alternative to hand tools; buy them by the hundred, use them (carefully) ten to twenty in sequence, then clean them for another use. To further explore this method, try using a metal notched pottery tool to dig beneath the surface. Fill the incisions and scrape back to reveal a larger scale of stripes.

Top to bottom: Incise-and-fill method using a pottery tool with multiple notches.

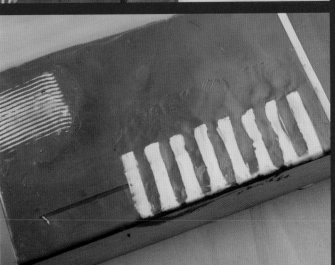

stencils

MATERIALS + TOOLS

- ☐ Basic encaustic tool kit (page 10)
- ☐ Cradled panel or other substrate prepared with a smooth encaustic surface
- ☐ Plastic stencils, perforated tape, gridded tape, or other stencils or objects with openings that will create pattern
- ☐ Brayer
- ☐ Waxed paper
- ☐ Pottery tool for scraping

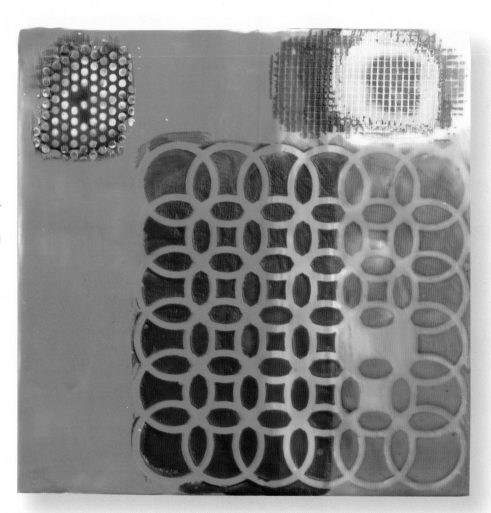

Stencils come in many forms; pre-cut stencils made of plastic, cardboard, or metal are readily available. For something original, it's easy to make your own from freezer paper, masking tape, wide painter's tape, overhead-projector film, or plastic made for cutting stencils. Try found stencils such as perforated tape as well. Start with simple shapes as you learn and practice.

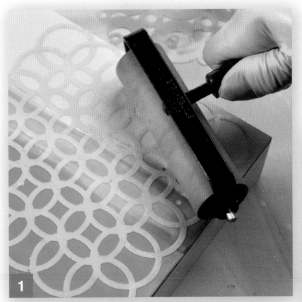

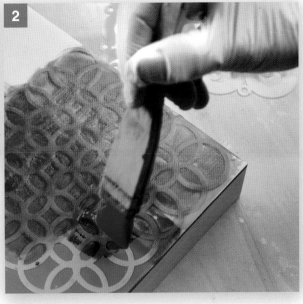

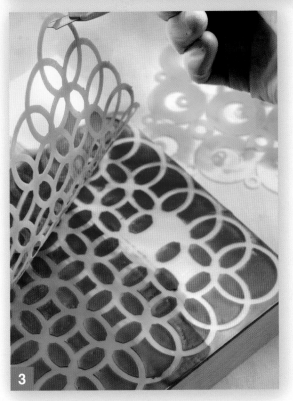

steps

1 | Begin with a surface that's slightly warm and very smooth. **Position** a stencil on the wax and cover it with a piece of waxed paper. With light pressure, **roll over** the stencil with a brayer until it is adhered to the wax. Remove the wax paper and check to be sure that there is full contact between the stencil and the wax.

2 | **Melt** encaustic paint on your palette. With a natural-bristle brush, **apply** encaustic paint to the open areas of the stencil. **Lightly fuse** and wait for the wax to lose its shine. Encaustic paint dries almost instantly and is ready to be painted over as soon as it becomes matte instead of shiny.

3 | **Gently remove** the stencil to reveal the pattern.

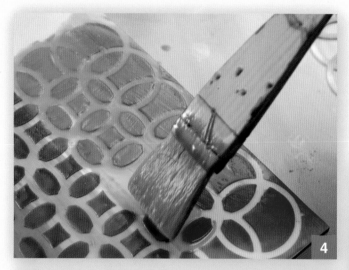

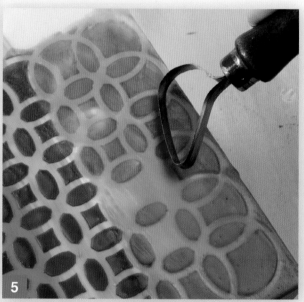

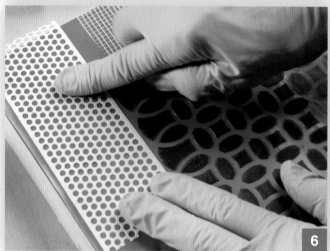

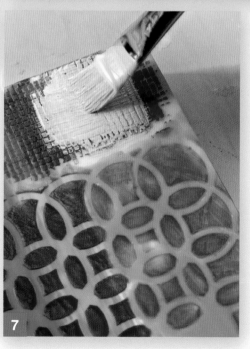

4 | If desired, **paint** another layer of color; fuse lightly and allow the paint to cool.

5 | **Scrape** back using a pottery tool to bring the layers to the same level.

6 | In the demonstration piece, I've also added **elements** of perforated tape; paint over the tape, fuse lightly while the tape is in place, then remove the tape. If desired, paint a contrasting color over what you just painted and scrape back.

7 | If desired, add another element of **mesh grid as a stencil.** I placed the grid, painted over it, and fused. I added another layer of paint that I partially scraped back.

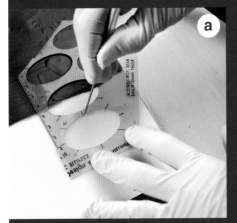

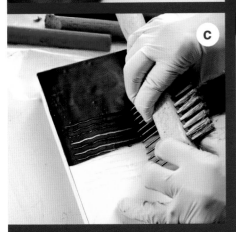

options for mark-making

In the demonstration beginning on page 84 , I use a variety of tools to create intentional marks in the surface of the wax. Here are some of my favorites. In each case, I'm working on a smooth, warm encaustic surface.

a | Scribe into the wax using a stencil (in this case, an oval template) and a bookbinder's awl.

b | Use a bookbinder's awl to prick marks into the wax.

c | Dig into the wax with the tines of a metal brush cleaner.

d | Stamp into the surface with unconventional objects, such as a piece of textured vinyl fabric; use a brayer and/or a burnishing tool to create a strong, consistent impression.

e | Work a metal or rubber stamp into the surface. Prep the stamp by dipping the face of the stamp into linseed or vegetable oil as a release agent. This step is important because stamps can stick into the wax and pull up many layers without a release agent. Rock the stamp from side to side to insure a good imprint. I used a metal alphabet stamp.

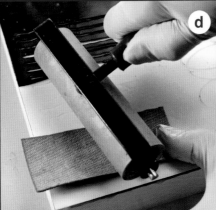

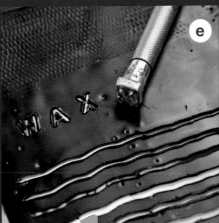

marks filled with *oil sticks*

MATERIALS + TOOLS

☐ Basic encaustic tool kit (page 10)

☐ Cradled panel or other substrate prepared with a smooth encaustic surface

☐ Mark-making tools such as a bookbinder's awl, stencils, and metal and rubber stamps

☐ Oil-based pigment sticks and blender stick

☐ Linseed oil, vegetable oil, or SoySolv II solvent

■ *Safety Note: Oil sticks contain linseed oil. Dispose of all items that the oil sticks touch (gloves, paper towels) in a metal trash can marked "flammable" and seal the can tightly with a metal lid. Wear vinyl or nitrile gloves or use barrier cream so your skin does not absorb pigment; some, such as cadmiums, are heavy metals and should not be ingested. Crumpled linseed oil-soaked rags can combust when the oil reaches its drying point. I also like to pour several cups of water in the trash can.*

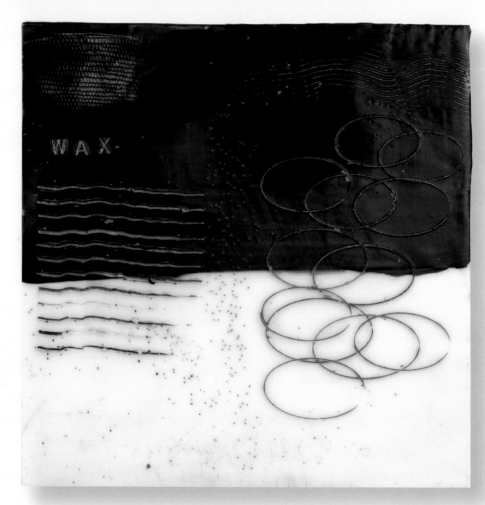

Use oil-based pigment sticks (I like Pigment Sticks by R&F Handmade Paints) to fill incisions and marks on an encaustic surface. I'll often use a blending stick to lightly coat the depressions; the blending stick extends the pigment stick just as encaustic medium extends encaustic paint. Then I select a contrasting colored oil stick and rub the color onto the wax to fill the marks. Wiping away the excess oil reveals the filled marks.

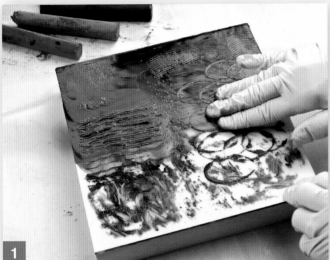

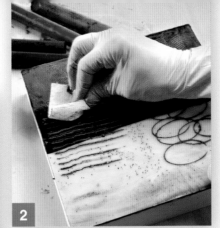

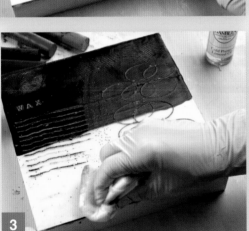

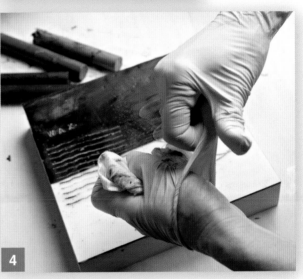

steps

1 | **Make marks** (page 83) on your smooth, warm encaustic surface. Put on gloves. Peel off any protective skin that may have formed on the sticks. Use a blending stick to extend the pigment sticks if desired. Coat the entire surface with pigment, rubbing the sticks into and below the surface and rubbing the color into the depressions with gloved hands.

2 | Use a paper towel or soft cloth rag to **remove** the excess pigment from the surface.

3 | To **remove** more oil and pigment from the surface, use linseed oil on a paper towel or rag. This will remove the remaining pigment that has stained the top surface.

4 | When you are satisfied, **hold** the paper towel in one glove and **roll back** your glove over the paper towel, trapping it in the used glove. **Dispose** in a metal container with a lid.

5 | To remove any remaining film, use linseed oil, vegetable oil, or SoySolv II on a paper towel. **Gently wipe** until the film is removed. **Dispose** of all items exposed to the oil and oil sticks as indicated in the safety note on page 84. I recommend that this be the top layer of your work because the exposure to air will allow the oil to dry. If you want to continue to apply wax, however, you must fuse first.

wax-based pencils and *crayons*

MATERIALS + TOOLS

☐ Basic encaustic tool kit (page 10)

☐ Cradled panel or other substrate prepared with a smooth encaustic surface

☐ An assortment of wax-based crayons such as Stabilo pencils, Caran d'Ache Neoart water-soluble wax pastels, Caran d'Ache Neocolor II Aquarelles, or china markers

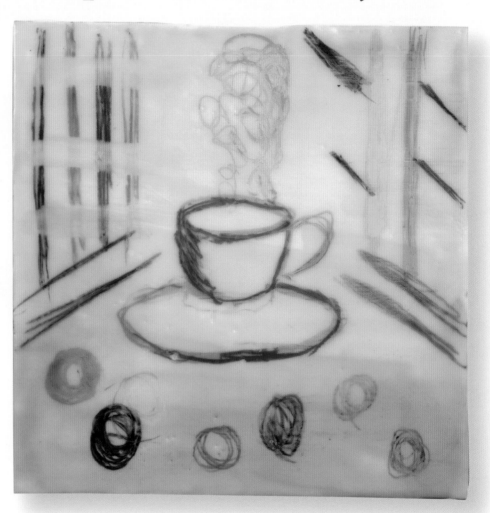

Stabilo pencils, Caran d'Ache crayons, china markers, Neocolor II crayons, Lyra 9B graphite pencils, and other wax-based implements can be used to draw on a cold encaustic surface. In most cases, you can use water to remove or change a line if you wish. You must fuse your drawing to make it permanent.

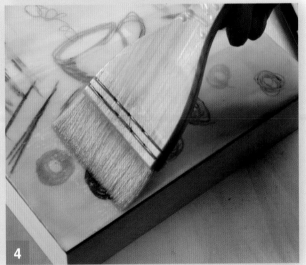

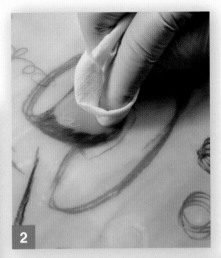

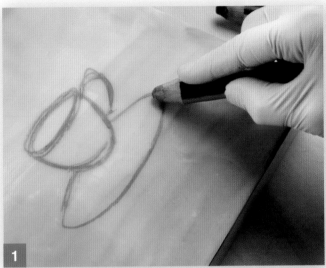

steps

1 | **Draw** directly on a smooth, cold encaustic surface with any of the pencils or markers listed.

2 | **Use** a little water on a paper towel to **shade, blend, remove, or change** lines. Some color residue may remain.

3 | **Fuse** to allow the wax to encapsulate the pigment and make your drawing permanent.

4 | **Brush** medium over the top.

5 | Continue **adding** color with crayons and pencils as desired; **fuse.**

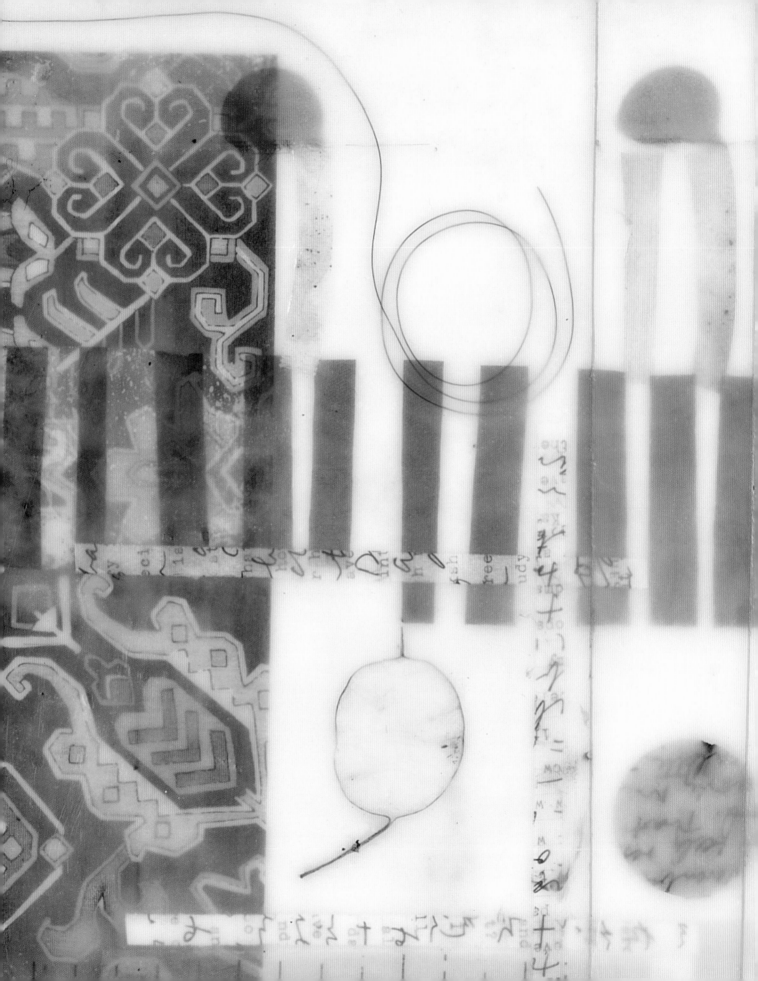

collage

Encaustic is well suited to collage techniques because the encaustic medium acts as a glue that holds everything together. Almost everything is fair game for inclusion. To insure success, remember that wax won't stick well to anything that is shiny or plastic, though sanding items such as coated paper can create better adhesion and make them appropriate for use in encaustic. Put a patterned object beneath the paper you are sanding for an interesting effect. You'll find more encaustic collage methods in the pages that follow.

collage with *papers*

- □ Basic encaustic tool kit (page 10)

- □ Cradled panel or other substrate prepared with a smooth encaustic surface

- □ Assortment of papers of various thicknesses, including printed paper napkins and die-cut paper shapes

- □ Encaustic pen tool with iron and stylus attachment or small quilter's iron

- □ Shim

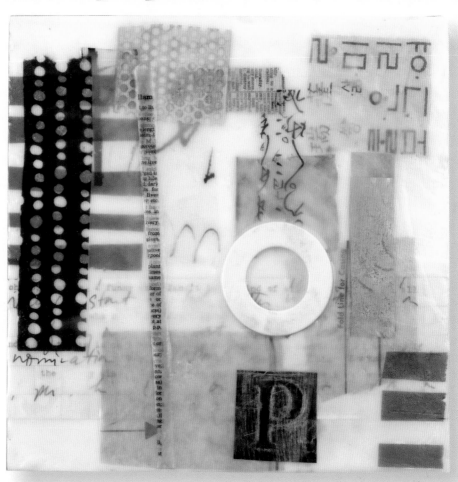

For this collage, I used an assortment of papers, including paper napkins and die-cut paper objects. A student introduced me to printed paper napkins—sold in grocery and party stores—for collage. These napkins typically have three layers; remove two by taking a piece of masking tape and pushing it into the back layer. The layers will begin to separate. Remove the back and middle layers to leave a very thin sheet of patterned paper perfect for transparent layering with wax.

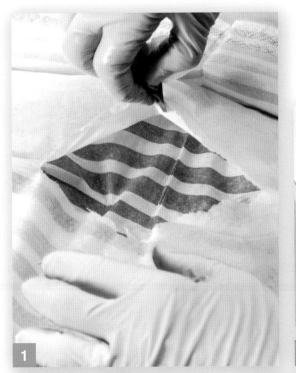

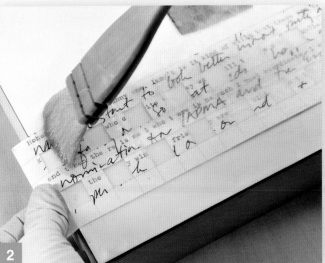

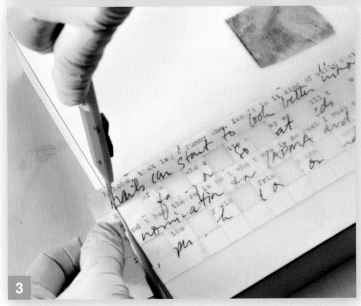

steps

1 | I begin by separating the top layer of printed paper napkins. **Peel away** and **discard** the back and middle layers, leaving a very thin printed paper that you can use effectively in collage.

2 | Choose relatively thin pieces of paper from your assortment and place onto the smooth encaustic surface. **Brush** medium over the paper.

3 | If the paper goes over the side of your panel, **cut** off the excess with a box cutter or X-Acto knife.

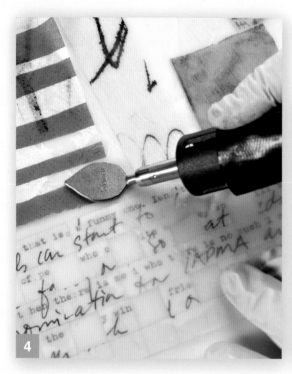

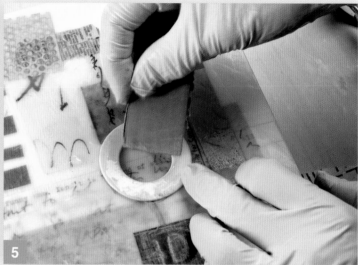

4

5

4 | **Add** more thin pieces of paper by placing them on the surface and ironing using the iron attachment on a hot wax stylus pen. A small quilter's iron will work if you turn down the temperature control to about 75 percent of maximum to avoid creating unhealthy smoke. Note that if you iron a napkin or paper onto a surface coated with encaustic paint, the pigment color will bleed through the paper. To prevent this, first paint a layer or two of medium and fuse to create a barrier.

5 | To adhere an element that is thicker or that might not want to stay down, **dip** it in medium to fully saturate (or paint some medium on your palette, and then **brush** the medium over your item to be collaged). Place the item on your substrate and press and scrape across it with a shim to remove excess wax. Pressing with a shim allows the item to submit and adhere to the surface.

6 | As you work, occasionally give the entire surface a **fuse.** *Caution:* If a piece of paper does not have wax on it and you fuse it with an open-flame torch, it may catch on fire. As a safety precaution, have a wet paper towel or cloth near your work. If paper does catch on fire, tap out the fire. Sometimes I intentionally burn the edges of a paper because it looks fantastic. It's always good to be safe, and have that wet paper towel nearby.

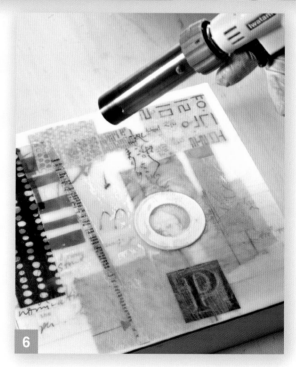

6

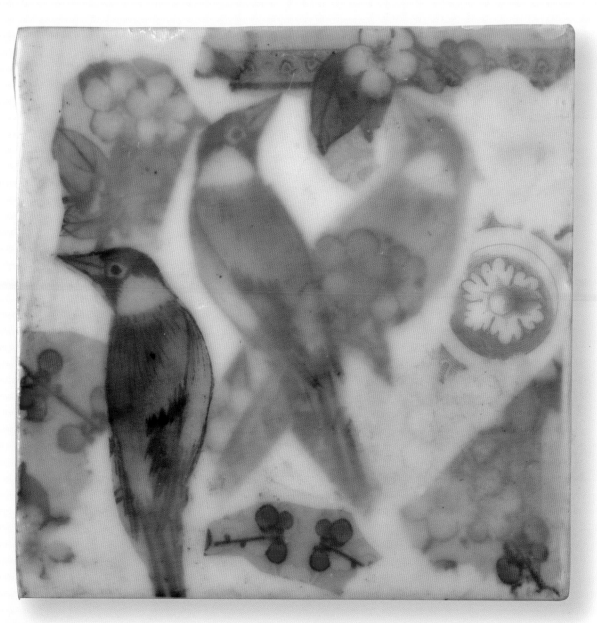

■ Variation: In this piece, I collaged the top layer of several printed napkins. The haziest of the birds is the layer I set down first, the middle one next, and the clearest bird is the top layer.

string as collage *element*

MATERIALS + TOOLS

☐ Basic encaustic tool kit (page 10)

☐ Cradled panel or other substrate prepared with a smooth encaustic surface

☐ Pencil

☐ Heavy string

☐ Burnishing tool

String, that most basic of materials, works well as a collage element. This technique is an easy, fun way to create dimension and subtlety on an encaustic surface.

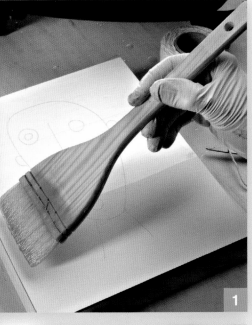

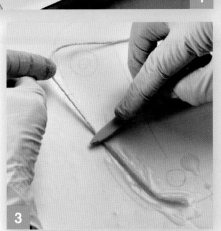

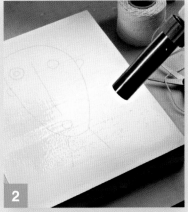

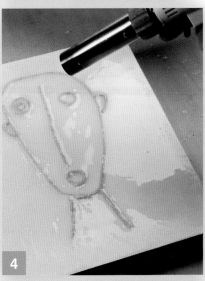

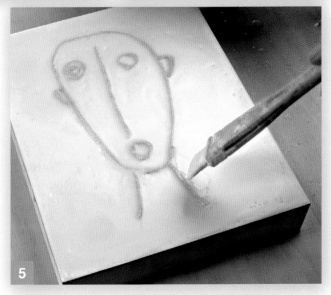

steps

1 | **Draw** a face in pencil on a smooth encaustic surface. Size the panel with several coats of medium, fusing between layers.

2 | **Fuse.**

3 | **Place** string in the shape of the head, following the pencil lines and pressing the string down into the wax with a burnishing tool.

4 | Continue placing string elements. **Paint** the surface with medium and fuse.

5 | **Paint** the entire surface with a pale white encaustic paint so the string becomes obscure and the portrait is raised above the surface. **Fuse.**

collage with fabrics, *fibers,* and plants

MATERIALS + TOOLS

☐ Basic encaustic tool kit (page 10)

☐ Cradled panel or other substrate with a smooth encaustic surface

☐ Silk organza fabric with a print (shown: red polka dots)

☐ Inkjet-printable silk organza sheets such as ExtravOrganza brand

☐ Assorted collage items (shown: dried leaf, waxed linen thread, colored sewing thread, dried used tea bags, small piece of metallic mesh screening, and sisal rope element)

☐ Shim

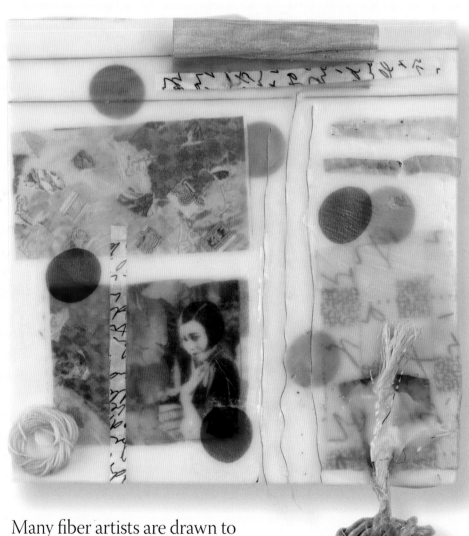

Many fiber artists are drawn to encaustic work just as I am, and enjoy incorporating fabric and fibers into wax. In this demonstration piece I add some modern technology with an inkjet-printable silk organza.

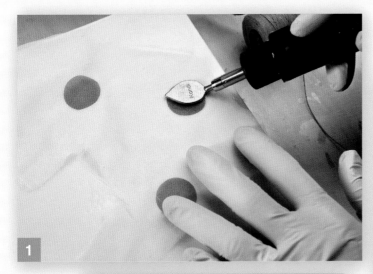

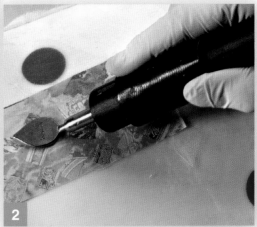

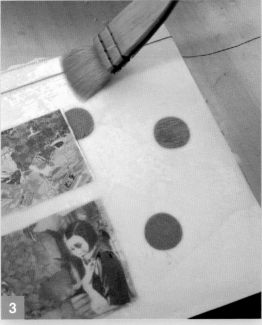

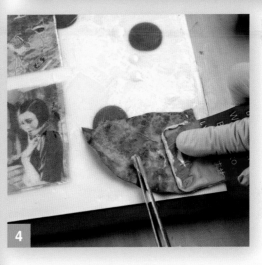

steps

1 | **Place** a piece of the organza on a sized panel and iron the fabric with an encaustic tool with iron attachment, starting in the center of the fabric and ironing out to the sides. The wax will encapsulate the fabric. Alternatively, place the fabric on the encaustic surface, brush medium onto it, and fuse.

2 | **Print** a color or black-and-white image onto a sheet of inkjet-printable silk organza. **Cut out** the image. Add it to the encaustic surface and iron as in Step 1.

3 | **Add** a piece of waxed linen thread to the panel and paint medium over it with a brush. Repeat.

4 | **Dip** a leaf into the melted medium on your palette. **Place** the leaf on the panel and press with a shim. Hold the leaf down with the shim as it cools so it will stay flat.

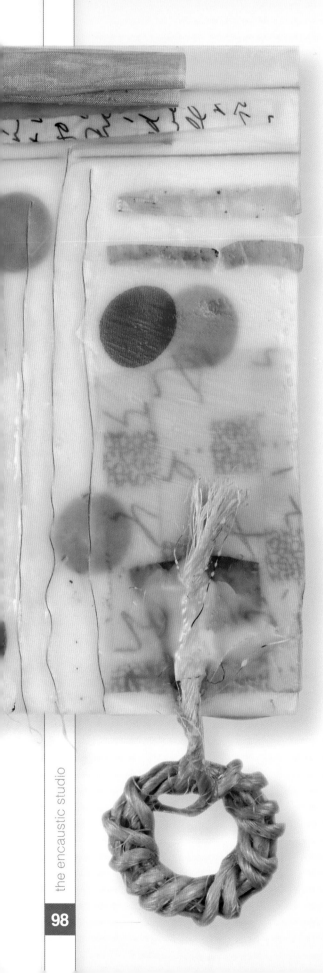

5 | **Add** thread and **paint** medium over it.

6 | **Add** another piece of inkjet-printable silk organza that you've printed with an image and **paint** medium over it.

7 | **Fuse** the entire surface.

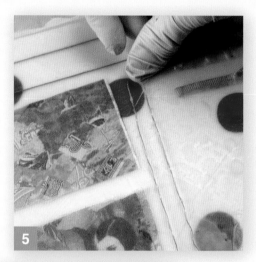
5

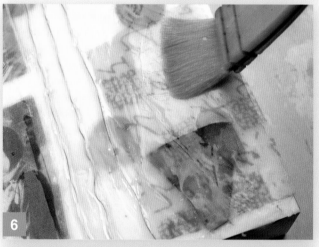
6

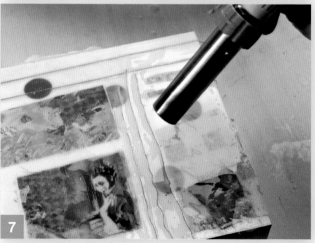
7

8 | If you like, add some pieces of dried tea bags, **burnish** them onto the surface, and **paint** over with medium.

9 | **Press** the piece of metallic mesh screening into the wax with a burnishing tool and apply medium to secure it. You may need quite a bit of medium to secure it to the panel.

10 | **Attach** a sisal rope element by burnishing the fiber onto the surface, then applying medium. Let cool. Add more medium. Fuse the surface to complete the piece.

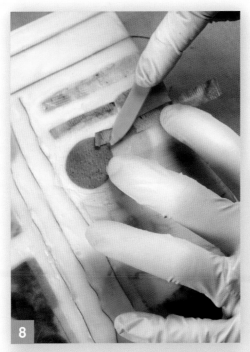

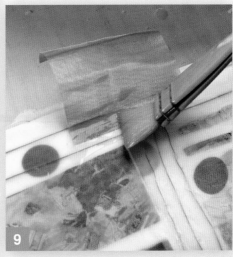

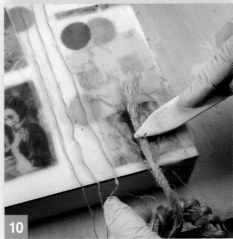

techniques

collage

99

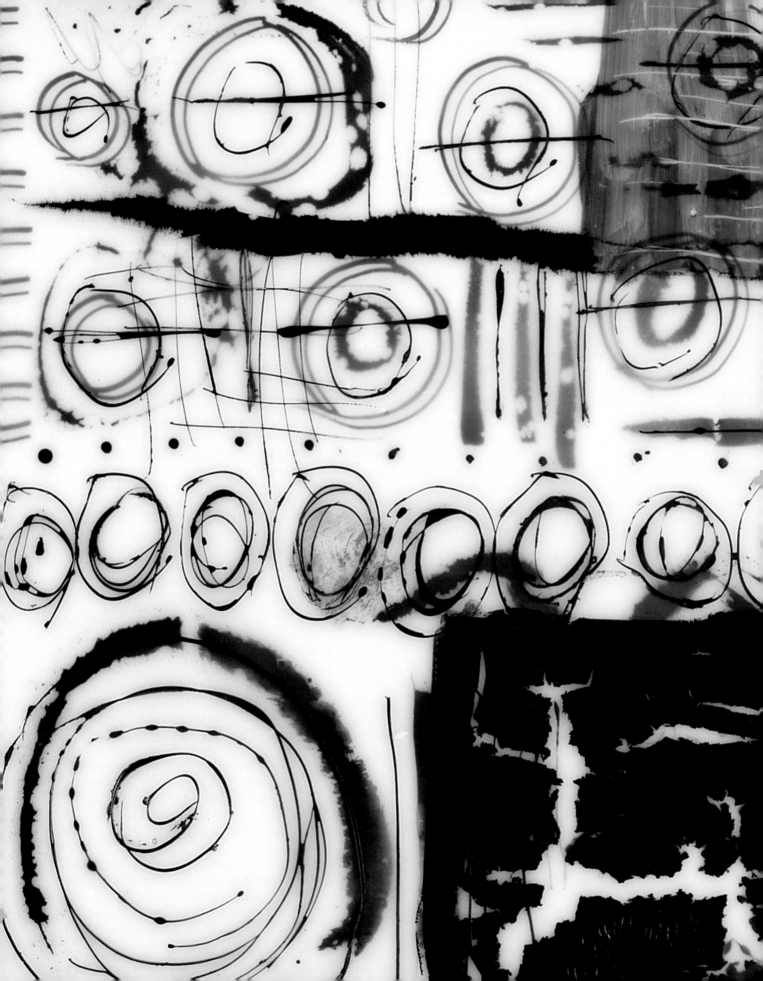

pigments

There are many ways to add pigment directly onto the wax surface without using encaustic paint, with beautiful results. In this section, I demonstrate some of my favorite alternate approaches to add color to your work. If encaustic paints are your primary source for color, these methods may take you in a new direction and inspire a new approach. And remember that pigment can be black—the rich, dark, fluid nature of India ink is stunning in combination with a white ground and encaustic medium.

powdered pigments
on paper or medium

MATERIALS + TOOLS

☐ Basic encaustic tool kit (page 10)

☐ Cradled panel, drywall surface, or other substrate painted with encaustic gesso

☐ Dust mask or respirator

☐ Chalk pastels or pan pastels

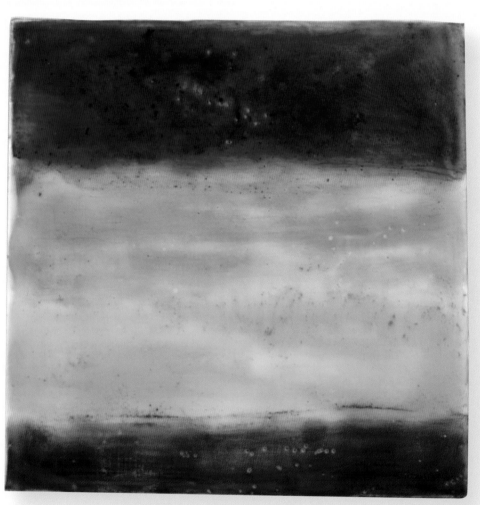

Deposit powered pigment right on a sized panel to achieve beautiful results without encaustic paints. Chalk pastels provide powdered pigment in many colors. Pan pastels are also effective for this technique.

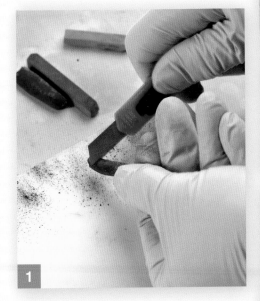

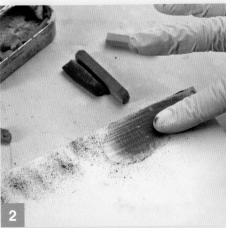

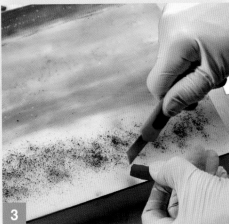

steps

1 | Put on gloves and a dust mask. With a box cutter, razor blade, or X-Acto knife, carefully begin to **scrape** and **flick** the pigment from a chalk pastel onto a smooth, cool, sized encaustic surface.

2 | With a gloved finger, **rub** the pigment into the wax. **Fuse** lightly.

3 | Repeat Steps 1 and 2 with additional colors.

tip you can use this method with many powdered products, such as coffee grounds, tea, cosmetic face powder, and even herbs such as turmeric. Most of these are not lightfast, and will fade over time. You can also use rust: put iron or steel objects, steel wool, or iron powder right on a sized encaustic surface, then spray a solution of half water and half white vinegar over the surface. Allow this to dry, and *voila*—rust on the surface. When it dries, you can paint medium over the rusted area, fuse, and continue to layer. *From left to right: cosmetic face powder, rust, coffee grounds, tea leaves*

india *ink*

MATERIALS + TOOLS

☐ Basic encaustic tool kit (page 10)

☐ Cradled panel, drywall surface, or other substrate painted with encaustic gesso

☐ India ink

☐ India ink stamp pad

☐ Bamboo skewers

☐ Quill pen or calligraphy pen and nib

☐ *Optional:* Discarded bamboo blind section

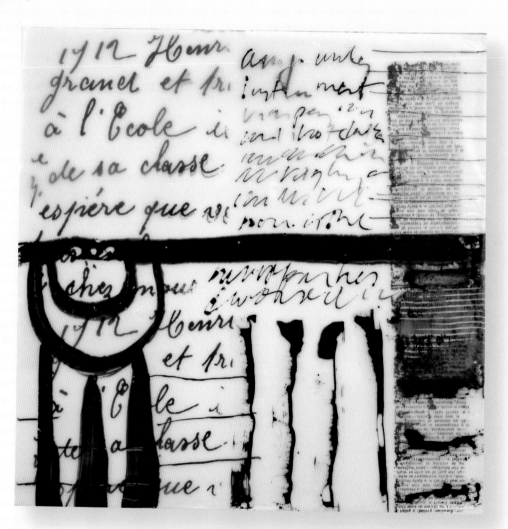

India ink can be used to draw directly on wax (or other surfaces such as drywall mud or paper). Fusing is not necessary to make the ink permanent, but the ink must dry completely. After the ink is dry, additional layers of wax may be applied. The more you apply, the more unpredictable it becomes.

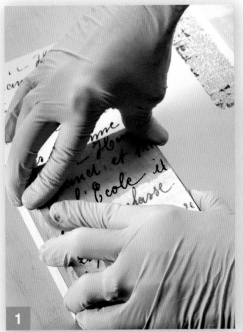

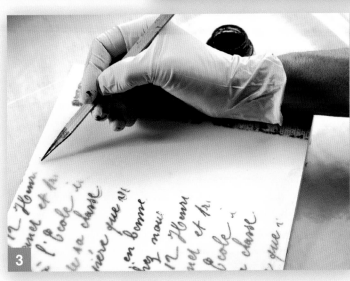

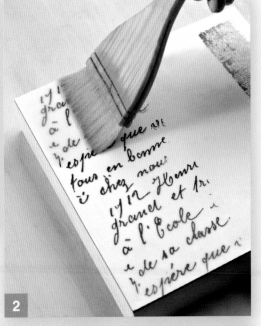

steps

1 | **Load** stamps with India ink stamp pad and stamp directly on a cradled panel, dry and cured drywall mud, or a substrate that's been painted with encaustic gesso. Let dry.

2 | **Coat** panel with encaustic medium two or three times, **fusing** between layers. Let cool.

3 | **Dip** a bamboo skewer into India ink and begin **writing** and **drawing** on the cool wax surface.

4 | You may also **paint** wider strokes with a bamboo slat or brush and **write** words with a quill pen or calligraphy pen.

5 │ When the India ink is partially dry, you can **spread** a portion of it on the wax like a stain.

6 │ You may also **scratch** through the dried ink.

7 │ India ink is permanent when dry, so you can freely add medium and continue to **paint** more layers. The first layers will become more obscure as you add more medium. Medium cures over time, and you'll be able to see deeper into the wax as time goes on, especially if you buff with a soft cloth.

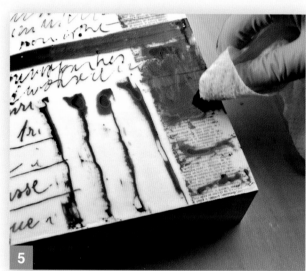

tip
Try using India ink stamp pads with rubber stamps or found-object stamps.

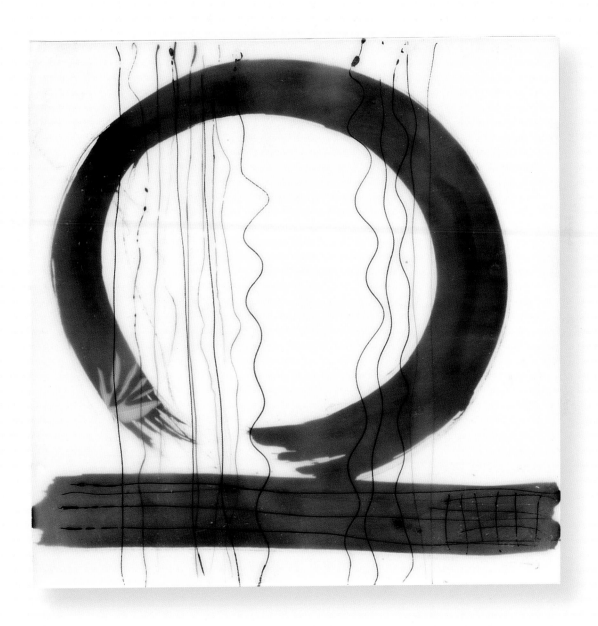

■*Another example of India ink as pigment.*

water-soluble *pencils*

MATERIALS + TOOLS

☐ Basic encaustic tool kit (page 10)

☐ Cradled panel, drywall surface, or other substrate painted with encaustic gesso

☐ Permanent watercolor pencils such as Derwent Inktense (or watercolor paints)

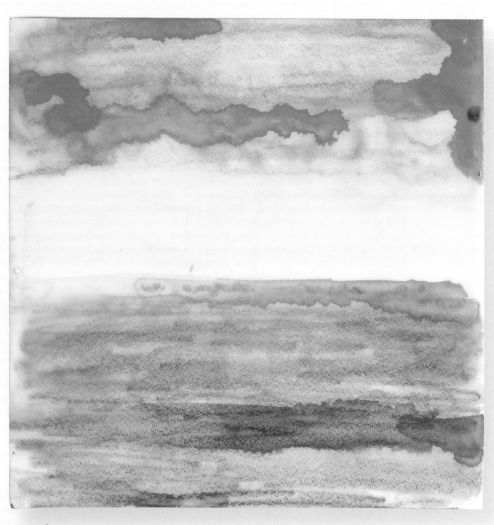

Apply water-soluble pencils (or watercolor paints) directly on a cradled Encausticbord panel, on drywall mud, or on another substrate primed with encaustic gesso. In this demonstration piece, I used Derwent Inktense permanent watercolor pencils.

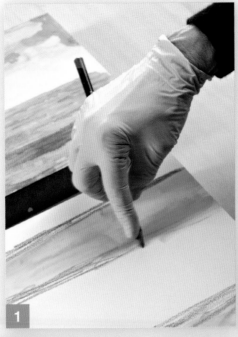

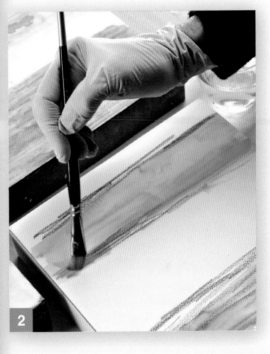

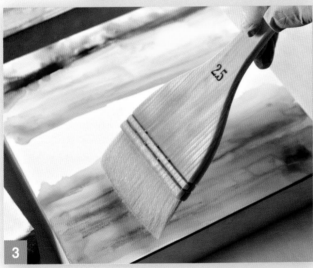

steps

1 | **Draw** onto the surface with watercolor pencil or **paint** the surface with watercolor or gouache.

2 | **Brush** water onto the drawn area to spread the color. Let dry.

3 | **Paint** the surface with encaustic medium. Fuse. You now have a fairly complex image onto which you could perform a multitude of techniques.

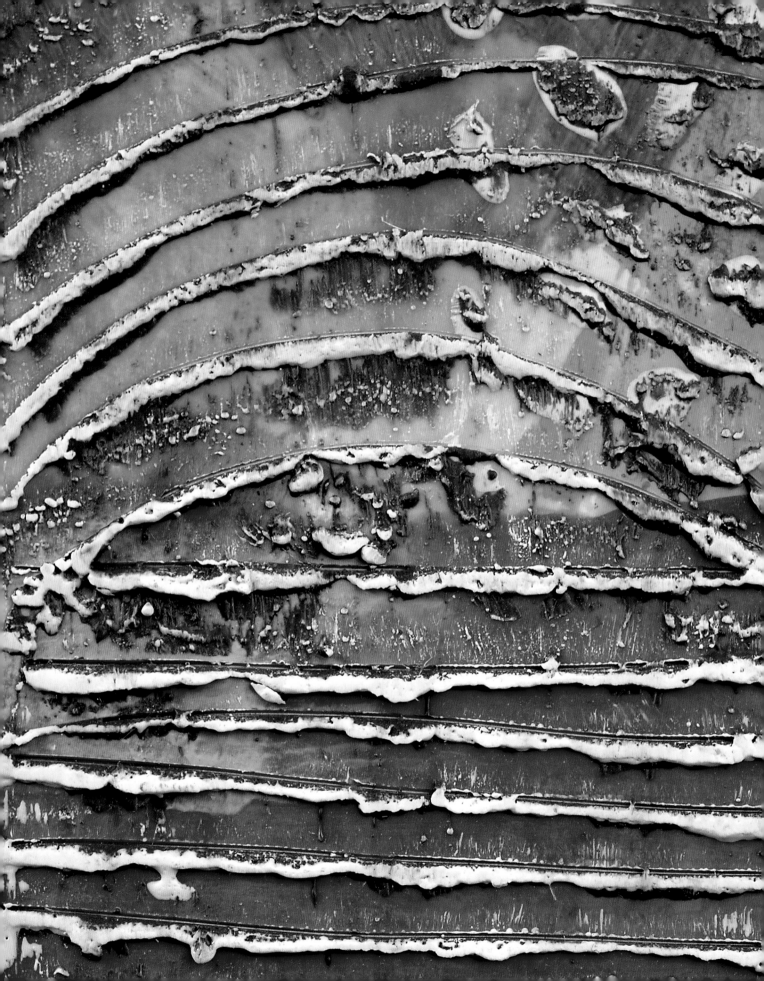

dimensions

Encaustic medium, that versatile combination of beeswax and damar resin, can be cast, carved, poured, and sculpted into three-dimensional forms. You may find it interesting to experiment with other waxes, such as casting waxes, for dimensional work. I like to keep it simple and decrease my variables, so I continue to work with encaustic medium and encaustic paints—they provide me with enough complexity, variety, and possibilities for experimentation.

cast and pour 3-D *shapes*

MATERIALS + TOOLS

- ☐ Basic encaustic tool kit (page 10)
- ☐ Cradled panel with at least ten layers of encaustic paint or medium, fused between each layer
- ☐ Two-part silicon mold compound such as Mold-n-Pour
- ☐ Metal paint pan or measuring cup with lip
- ☐ X-Acto knife
- ☐ Metal cookie cutters (mine are round, but any shape works)

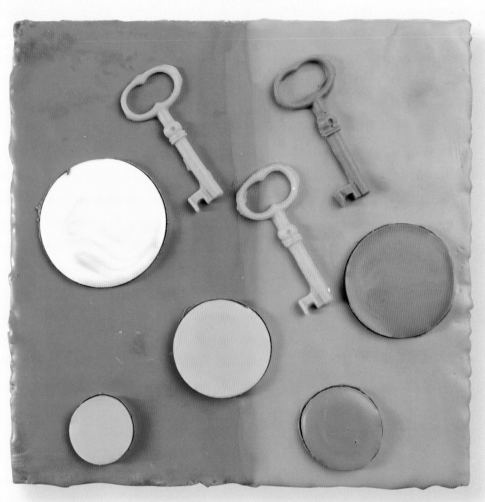

It's easy to cast three-dimensional objects and adhere them directly to your panel or substrate. I use Mold-n-Pour, a two-part quick-set custom mold compound by Suze Weinberg Melt Art, to quickly cast wax shapes such as the keys shown here. In the second part of this demonstration, I pour wax onto the substrate using a cookie-cutter "fence."

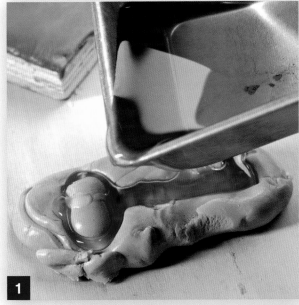

1

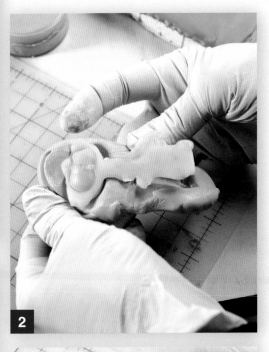

2

3

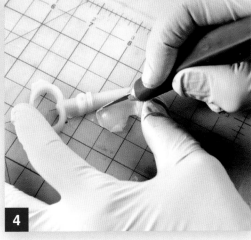

4

steps
cast 3-D shapes in a silicon mold

1 | **Follow** the instructions on the package for the mold compound to prepare your mold. **Press** an object into the compound to create an impression. **Pour** melted medium or encaustic paint into the mold and allow to harden.

2 | Gently **manipulate** the mold to **release the hardened shape.** Reuse the silicon mold to cast as many shapes as you like; for this project, I made several in different colors.

3 | **Warm** an X-Acto knife or box cutter blade on your encaustic palette.

4 | **Cut away** any excess wax from the cast shapes with the warm tool.

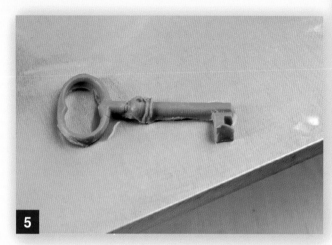

5

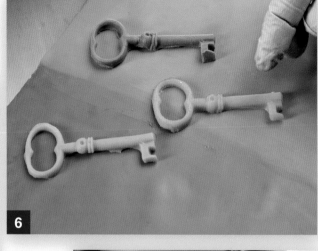

6

7

5 | **Warm** the cast shapes that you've made on the palette.

6 | **Place** the molten side of the warmed shape on the warm encaustic surface of your panel, **pressing lightly.** Continue this process until you have adhered all the elements.

pour 3-D shapes

7 | **Heat** metal cookie cutter shapes on the palette.

8 | Wearing gloves, **place** a hot cookie cutter on your substrate. **Gently push** the cookie cutter into the surface to form an airtight bond that will prevent the poured molten wax from seeping out onto the surface. Be sure to wear gloves as the cookie cutter will be hot. Repeat this with as many shapes as you like.

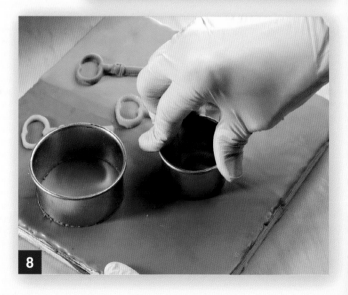

8

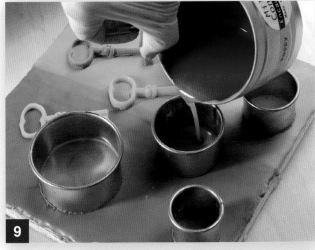

9

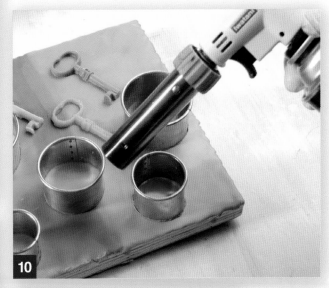

10

11

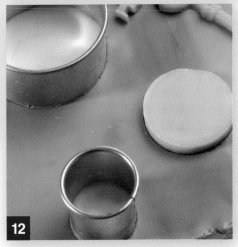

12

9 | **Melt** medium or encaustic paint in metal tins that are small enough to safely handle, and **pour** into the interior of the cookie cutter shapes. Let dry (the wax will turn from shiny to matte).

10 | With your heat gun or torch, **lightly heat** the upper rim of each metal cookie cutter, just enough to release the cookie cutter.

11 | With a paper towel and gloved hands, **gently twist** the cookie cutter clockwise and counterclockwise until you can gently **lift the metal form straight up.** It's almost like opening a champagne cork.

12 | Your shape is intact. Continue until all cookie cutters are removed. You may leave these shapes as **design elements** or continue to embellish them with transfers, collage, metal leaf, or other techniques.

tip For easy attachment of a three-dimensional object, try this: When pouring the encaustic paint into the silicon mold, add a small piece of cheesecloth to the molten wax. When it dries, use the cheesecloth as an anchor to "iron" the cast piece onto the surface of your substrate with the iron attachment on a wax stylus pen.

pour a level wax *surface*

MATERIALS + TOOLS

- ☐ Basic encaustic tool kit (page 10)
- ☐ Cradled panel or other substrate with adhered image
- ☐ Aluminum baking pan with high rim
- ☐ Skillet
- ☐ Metal measuring cup with pouring lip
- ☐ Object to place under panel to raise it

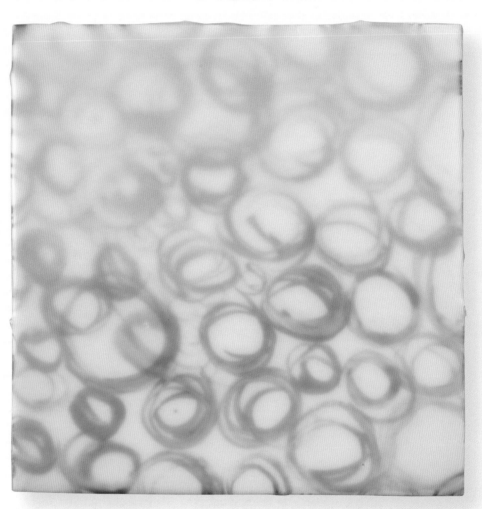

I use this method when I have imagery that I'd like to cover with a very thin layer of encaustic medium before adding additional layers and techniques—or simply to add more of the wax effect.

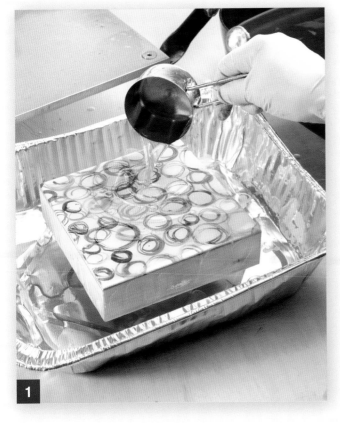

1

tip To reuse excess medium, put the baking pan in the freezer. When the medium has frozen solid, pop it out and re-melt.

steps

1 | **Adhere** an image to your substrate as shown on page 44 and let dry. **Heat** the substrate on your palette. **Place** an object such as a metal tin into the aluminum baking pan and place the warm substrate onto the tin. If you want the wax pour to be uniform on the surface, level the panel with shims as needed. **Melt** medium in the skillet. Using the metal measuring cup, pour medium over the surface of the substrate.

2 | Continue **pouring** until there is complete coverage. The excess medium will simply spill over the sides into the baking pan. In this pour, I did not use a level, so the wax pooled at one end, and mysteriously obscures the image a little bit.

tip To cover a large surface with medium or paint without an image beneath it, pour directly onto the surface after building a "fence" around the perimeter of the panel with masking tape or blue painter's tape. Start taping in the middle of one side of your panel with a portion of the tape extending above the top of the panel to trap the wax. Go around the perimeter of your panel with tape three times. With a burnishing tool, rub where the tape touches the wood to create a tight bond. Heat the panel, then pour the wax. On very large surfaces, turn off the fans in your studio as the wax dries; the air current can cause a patterning in the wax.

combine texture *and color*

MATERIALS + TOOLS

☐ Basic encaustic tool kit (page 10)

☐ Cradled panel with smooth encaustic surface

☐ Basic encaustic tools

☐ Skillet

☐ Bookbinder's awl

☐ Hake brush or coarse-bristled brush such as a chip brush with boar bristles

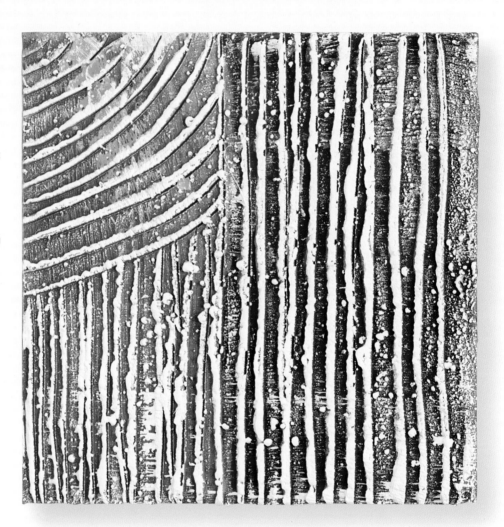

In this demonstration, I create texture by applying cool wax to a cool support. I begin with a sized panel and add a base color; subsequent layers of medium and encaustic paint create a rich, interesting surface.

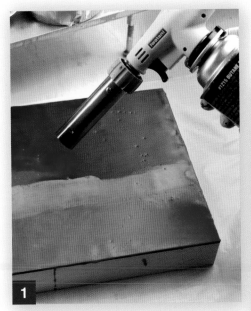

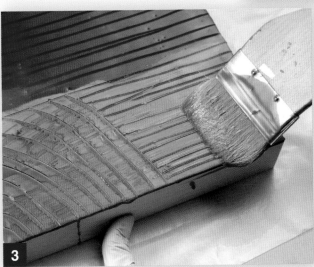

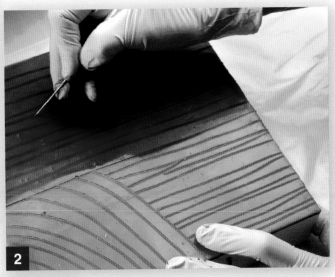

steps

1 | **Paint** a sized support with encaustic paint in a base color. This base color will be visible in the background of the finished piece. **Warm** the surface slightly with your heat gun or torch.

2 | **Dig** lines and patterns into the wax with a bookbinder's awl or other sharp pointed tool.

3 | **Cool** a second color of paint to about 150° to 170°F (65° to 76°C) by moving it away from the heat source or to the edge of your palette. Using a hake brush or chip brush, **paint** the surface with the cooled paint as follows: **dip** your hake brush or chip brush into the wax and lift it out and **slowly turn** and **rotate** the brush to further cool the wax, or hold your brush in front of a fan. When the shine of the paint on your brush disappears, start **painting. Drag** the brush across your waxy surface in the opposite direction of the scratches you have made until no paint comes off the brush.

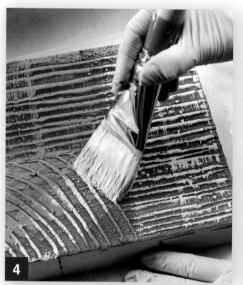

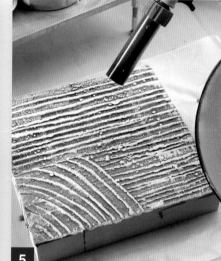

tip This technique contradicts the general encaustic rule that every layer is fused to the layer beneath. Because each layer is not entirely bonded to the one beneath, these works are more vulnerable and the raised areas can break or pop off.

4 | **Repeat** three or four times with additional colors.

5 | **Fuse** very lightly and let cool. If you fuse too much, the surface will go flat.

6 | Continue **painting and fusing** as described, until the desired amount of texture has been achieved.

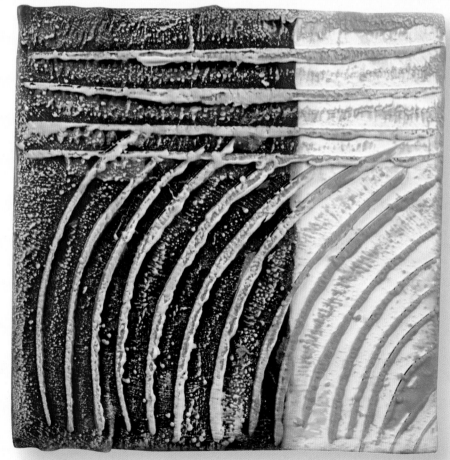

■ *Variation: Another example of texture and color combined.*

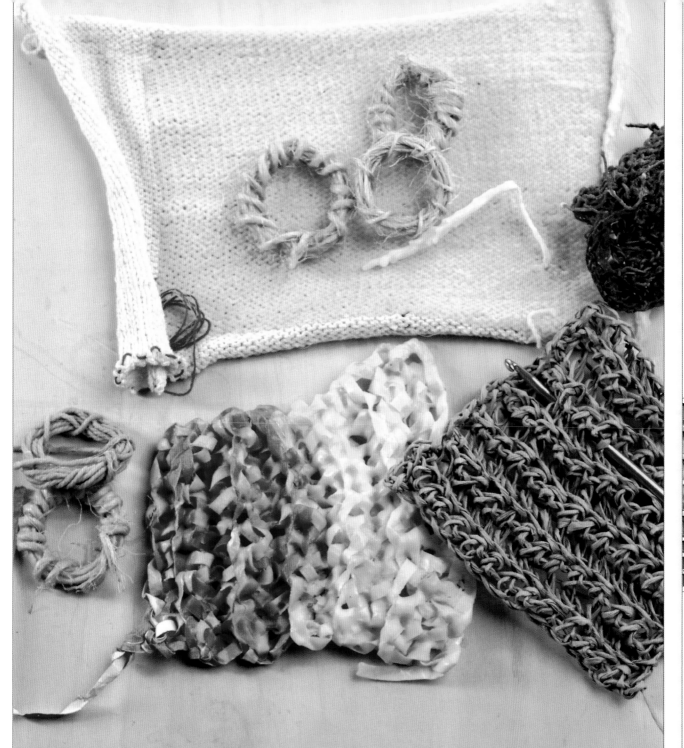

dipped dimensional fiber objects

This photograph shows a variety of knit, crocheted, and wrapped forms made from yarn, string, and paper. They have been dipped in encaustic medium and can be used as elements in encaustic collage. You need only a vat of molten wax and an armature or form to shape the fiber on, if you want it to be sculptural.

Give the armature or form a base layer of freezer paper or Tyvek so your dipped fiber will not stick to the form as it cools. If you decide you don't like the result, simply submerge it in wax again, and reform it around an armature. After dipping, let cool and remove from the armature.

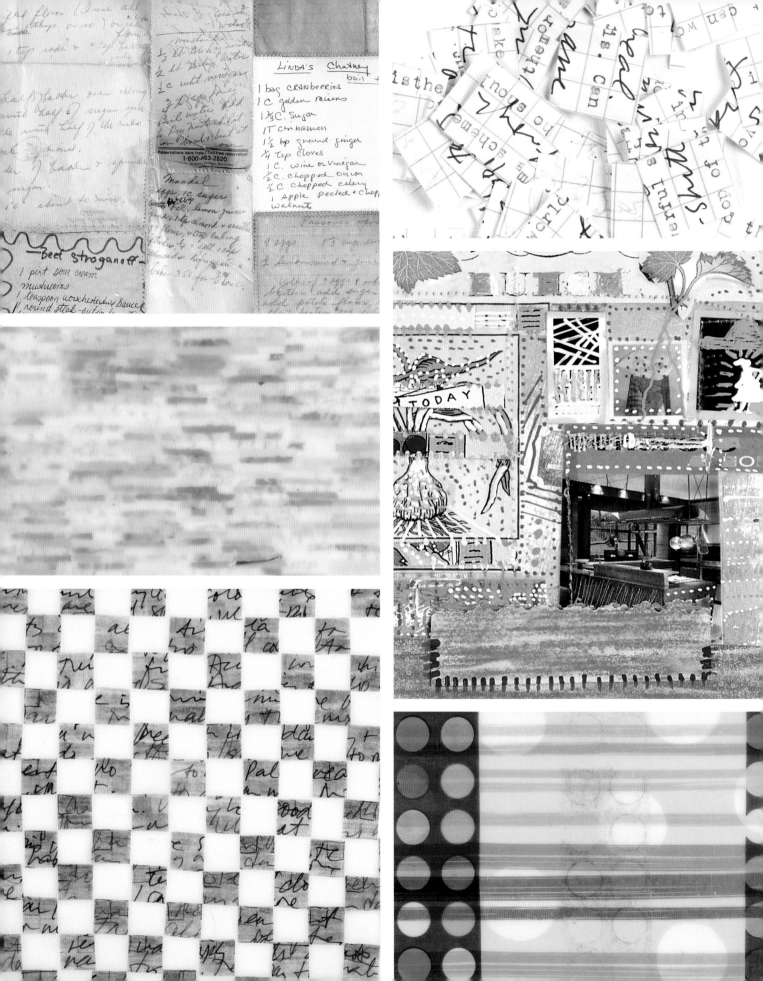

projects

Working in encaustic is a journey of exploration and experimentation for every artist. Each of the techniques you've learned in this book can be a starting point for limitless interpretation and expansion. The projects that follow will help you get started; they're easy and rewarding, and include some of my favorite themes, such as working with text, three-dimensional shapes, and collage and found objects. Just as with the previous techniques, you'll need a basic encaustic studio set-up (page 10) for each project; additional project-specific materials and tools are listed in the instructions.

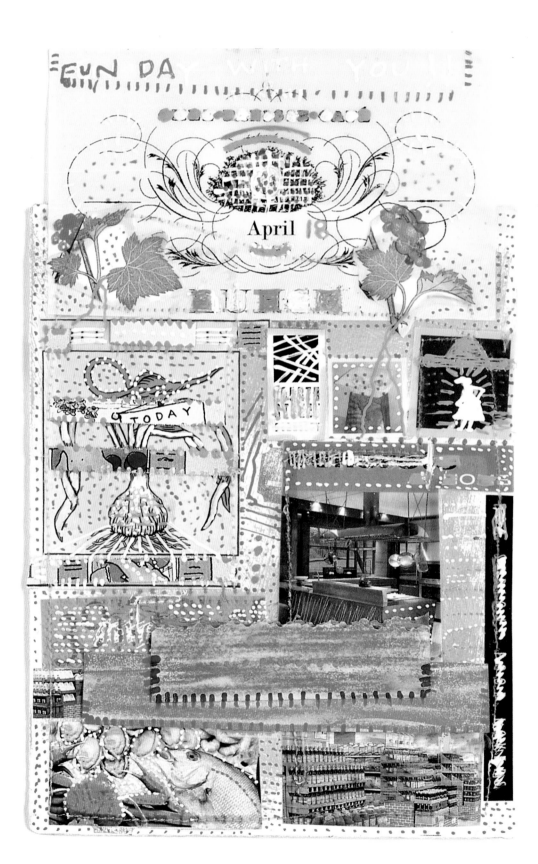

a day with you

Whenever you have a special day with a friend, collect mementos along the way, such as tickets, menus, business cards, and photos printed on matte paper, and make a collage in wax. After it's complete, and before you give it away, scan it and print it out for inclusion in a future collage or transfer. It's always good when your work can do double duty!

FINISHED SIZE
8" × 10" (20.5 × 25.5 cm)

MATERIALS + TOOLS
- 8" × 10" (20.5 × 25.5 cm) sheet of heavy paper
- Paper mementos from a special day, such as restaurant menus, business cards, photos, prints
- Vat of encaustic medium large enough to submerge paper
- Needles and thread
- Wax stylus pen
- Sewing machine
- *Optional*: Waxed linen thread, fabrics, translucent paper scraps, gold leaf

steps

1 | **Sew** your paper mementos in a collage or composition on the piece of heavy paper.

2 | **Melt medium** in a vat large enough to dip the paper. Dip the stitched collage into the vat. Let dry.

3 | Continue **hand-stitching** more items, such as thin translucent papers or fabrics, to the **surface.** Some options:

+ Use waxed linen thread to stitch on the collage.

+ Add photo transfers.

+ Add images you've printed on inkjet-printable organza.

+ Add more materials, **threads, string,** or other objects to the top layer.

+ **Embellish** the collage with **gold leaf** in some areas as a final layer.

+ No fusing is necessary; touch up the collage with a hot wax stylus pen where needed to **encapsulate** the collage items in the wax.

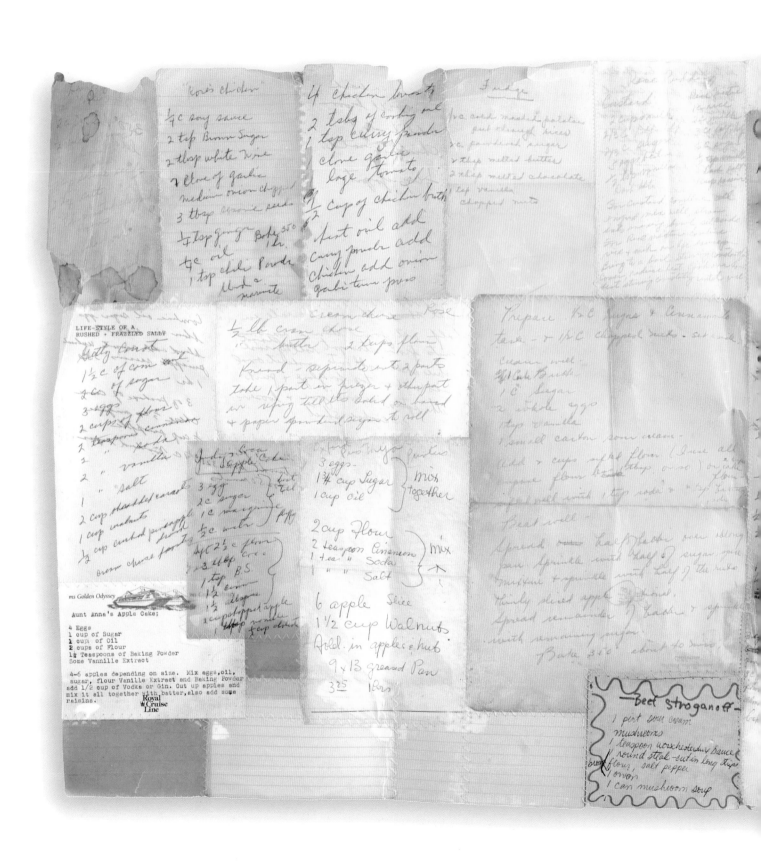

"Koki's Chicken"

¼ C soy sauce
2 tsp Brown Sugar
2 tbsp white wine
2 clove of garlic
medium onion chopped
3 tbsp sesame seeds
½ tsp ginger Bake 350
¼ C oil 1 hr.
1 tsp chili powder
Mix & marinate

4 Chicken breasts
2 tbls of cooking oil
1 tsp curry powder
1 clove garlic
1 large tomato
½ cup of chicken broth

Heat oil add
curry powder add
chicken add onion
garlic tomato press

Fudge

3 c cold mashed potatoes
put through ricer
5 c powdered sugar
3 tbsp melted butter
3 tbsp melted chocolate
1 tsp vanilla
chopped nuts

LIFE-STYLE OF A
RUSHED + FRAZZLED SALLY

Betty Crocker
1½ c of corn oil
2 c of sugar
3 eggs
2 cups of flour
2 teaspoons cinnamon
2 " soda
2 " vanilla
2 " salt
1
2 cup shredded carrots
1 cup walnuts
1½ cup crushed pineapple
½ cup ... cream cheese frosting

½ lb cream cheese
½ cup butter 2 cups flour

Knead - separate into 2 parts
take 1 part in freezer & the other
in refrig till its solid or hard
+ paper powdered sugar to roll

Cream cheese ... Rose

Apple Cake
3 egg
2 c sugar
1 c mayonnaise
½ c water
... 2½ c flour
... 3 tbsp cocoa
1 tsp B.S.
½ tsp cinn
½ tsp allspice
2 cup chopped apple
1 tbsp vanilla
1 cup chocolate ...

3 eggs-
1¾ cup Sugar } Mix
1 cup oil together

2 cup Flour
2 teaspoon Cinnamon }
1 tea " Soda } Mix
1 " " Salt }

6 apple slice
1½ cup Walnuts
fold in apples & nuts
9 x 13 greased Pan
3 25 1 hr

Prepare ¾ C Sugar & Cinnamon
take + 1½ C chopped nuts - set aside

Cream well
½ C Cake Butter
1 C Sugar
2 whole eggs
1 tbsp vanilla
1 small carton sour cream -
add 2 cups of all flour (I use all
purpose flour ... tbsp or so) or sift
self oil with 1 tsp soda & ... tsp ...

Beat well -

Spread over half batter over oblong
pan sprinkle with half of sugar ...
mixture + sprinkle with half of the nuts
finely diced apple (optional)
Spread remainder of batter & sprinkle
with remaining sugar
Bake 350 about 40 min

ms Golden Odyssey

Aunt Anna's Apple Cake;

4 Eggs
1 cup of Sugar
1 cup of Oil
2 cups of Flour
1½ Teaspoons of Baking Powder
Some Vannille Extract

4-6 apples depending on size. Mix eggs, oil,
sugar, flour Vanille Extract and Baking Powder
add 1/2 cup of Vodka or Gin. Cut up apples and
mix it all together with batter, also add some
raisins.

Royal
Cruise
Line

— Beef Stroganoff —

1 pint sour cream
mushrooms
1 teaspoon worchestershire sauce
round steak - cut in long strips
flour, salt pepper
butter
1 onion
1 can mushroom soup

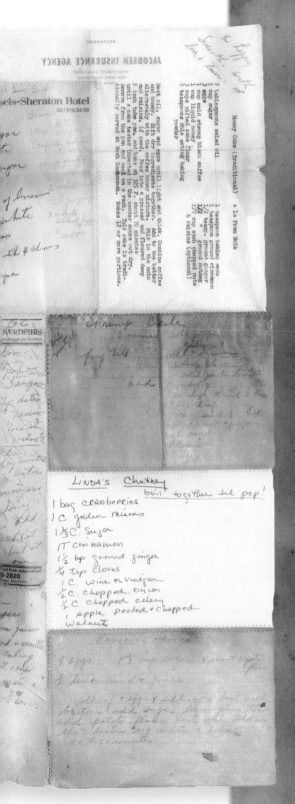

mom's recipes

Handwritten recipes are becoming a thing of the past, with all of our digital devices and easy access to recipes on the Internet. If you found your mother's wooden or metal recipe box fascinating when you were a child, this is a way to preserve your family's recipes for your favorite dishes in a beautiful artwork. Try this same technique with vintage knitting instructions or canceled checks.

FINISHED SIZE
8" × 10" (20.5 × 25.5 cm)

MATERIALS + TOOLS

- Old handwritten recipes, such as recipes on index cards, cut-out recipes from magazines, old coupons, and newspaper clippings of recipes

- Document repair tape or other pH-neutral tape

- Sewing machine

steps

1 | Arrange your recipes in a way that's visually pleasing and meaningful to you, whether chronological, with your favorites in the center, or randomly.

2 | Using document repair tape, **tape** adjacent edges of recipes together on the back forming long strips.

3 | Add zigzag stitching on the front of the strips to secure and embellish the recipes. You may leave them in strips, or use zigzag stitching to join the entire composition.

4 | If your recipes are in strips, **dip** strips in a vat of melted medium. If the composition is larger, **brush** medium on your palette, laying down the sewn recipes, and paint medium over them until the paper becomes translucent. Continue until all the paper is covered and saturated with encaustic medium.

5 | Fusing is not necessary with this piece. To present this type of collage, I like to screw two flat-head screws into the wall so that they extend slightly from the wall and attach tiny magnets (see Resources, page 156) to the back of the work. The magnets will grip the screws.

...me... ...at... ...ola...

...say. She yelled at me for not being able to read a... ...dow... ...at old... ...ou... ...new trouble... peg... ...ld...

art scholarship?... So my mom... either mentally... red...

...can't do math, girls aren't good at math. I can't... ...to cu...

next to that ole. That looks terrible. You are pay. Bow...

me, saying WHO DO YOU THINK YOU ARE!... leaving... ...here... we not... ...

music so I couldn't hear her while party - woman... ...that...

...ath to... myself that I was coordinated, skillful and even gazelle love... ...didn't...

...heard that she was the clumsy, not me. I was in...

...all along which I carried all my life. Now when...

...out of the room. He is fragile... an __ so...

true grid

Journaling is an important part of my artistic practice. I often shred, cut, or alter my writing and reconfigure the pieces in my work, so that I maintain the energy and content of the written word—revealing and concealing simultaneously. While working on this book, I found some paper with a large grid. After writing on it, then typing on it, I began cutting out the squares, and my True Grid series was born. I use both the grid and the cut-out squares. See more of the series on pages 130–133.

FINISHED SIZE
As shown, 8" × 8" (20.5 × 20.5 cm) or 8" × 10" (20.5 × 25.5 cm)

MATERIALS + TOOLS

- Graph paper with ¼" (6 mm) grid or larger
- Cradled panel or other substrate with a smooth encaustic surface
- Pens or writing instruments
- Metal ruler
- Waxed paper
- Burnishing tool
- Hot wax stylus with iron attachment
- *Optional:* Typewriter

steps
openwork grid

1 | This version uses the openwork grid that remains after alternating squares have been cut away.

2 | **Journal and/or type** on your gridded or lined paper.

3 | Using the metal ruler, an X-Acto knife or box cutter with a sharp blade, and a self-healing cutting mat, **cut** out alternate squares checkerboard-style, creating an open grid or pattern in the paper.

4 | **Place** the cut paper onto a sized panel. Add a sheet of waxed paper on top. **Burnish.**

5 | **Remove** the waxed paper. Using a wax stylus pen with the iron tip, **iron** the paper surface so that the medium from the sized panel melts and encapsulates the paper.

6 | **Brush** a layer of medium over the surface. **Fuse.** Add more layers of medium as desired, fusing after each layer.

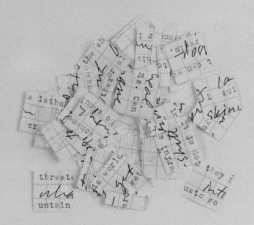

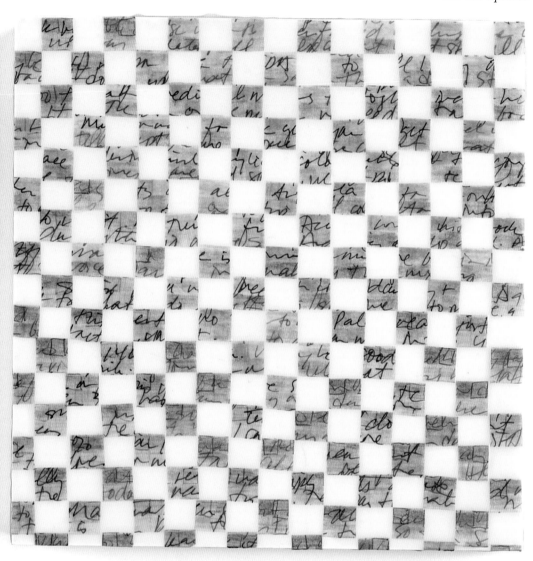

checkerboard from cut-out squares

1 | This version shows a checkerboard pattern made from the tiny squares cut from the gridded paper. Starting at one end of a cool, sized panel, **place** a square onto the surface and rub with a burnishing tool. As above, use a sheet of waxed paper over the square to aid the burnishing process.

2 | Continue as in Step 1 with the next square until the entire surface of the wax has a **checkerboard** of squares **burnished** to the surface.

I don't measure the squares or mark lines for placement; I start at one end and work from one side to the end, eyeballing the spacing. If there is any overhang when I get to the end, I simply slice the remainder with an X-Acto knife or box cutter.

3 | **Paint** medium over the entire surface. **Fuse.**

4 | Repeat, adding a layer of medium, followed by fusing, until the top surface is completely smooth. This may require several layers. If the paper squares curl up, **burnish** them while the surface is still warm.

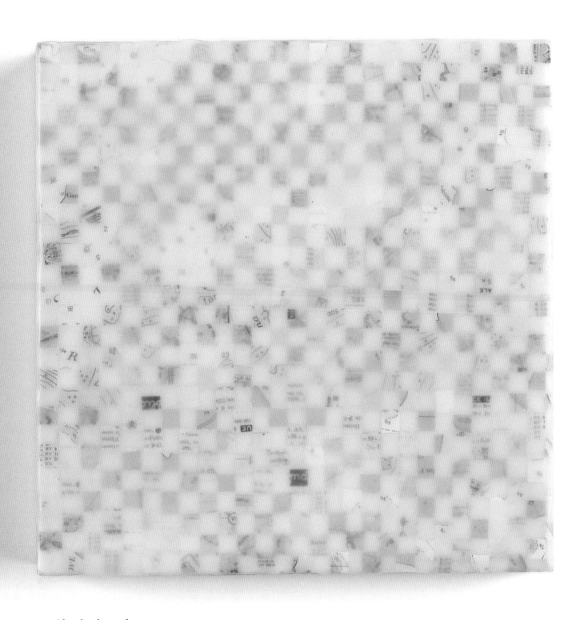

■ *Checkerboard*

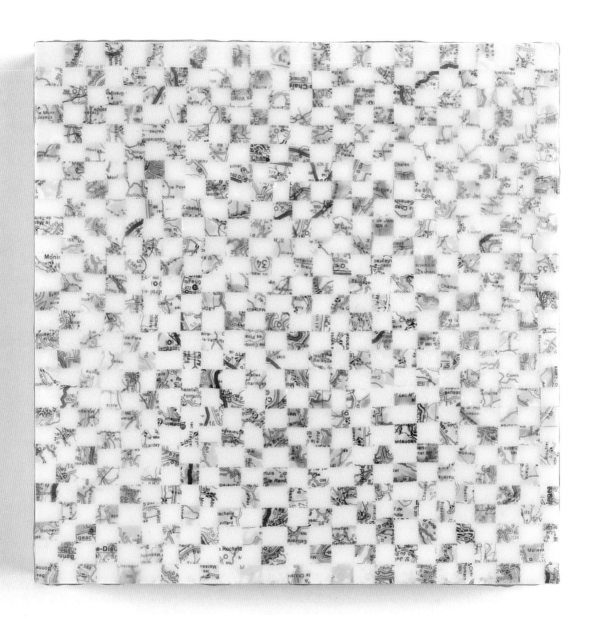

■ *True Grid checker-
board variation*

■ *True Grid openwork
grid variation*

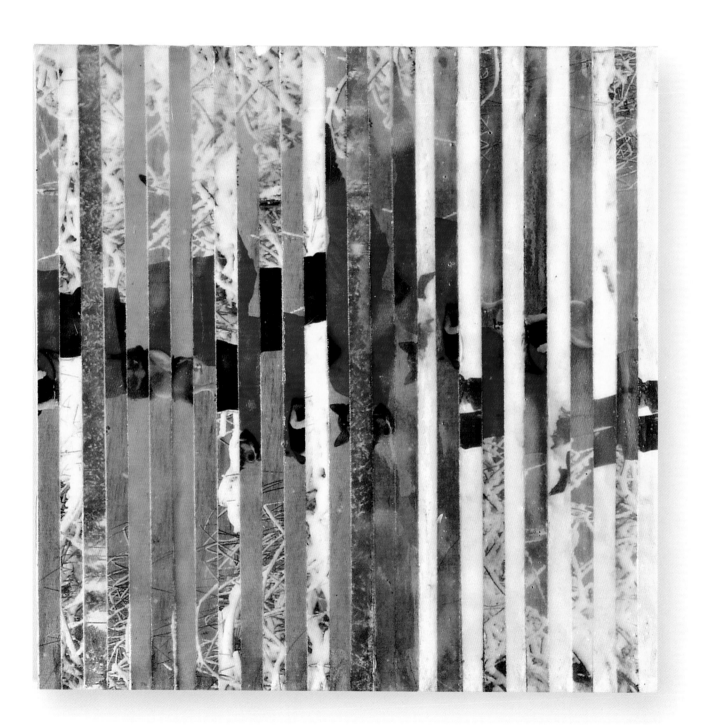

distorted
image

For this project, I shredded multiple copies of a printed image of a painting that I loved. I cut the image in different ways—first with vertical cuts, then horizontal ones, then randomly—before rearranging the shreds and gluing them on a cradled panel.

FINISHED SIZE
8" × 8" (20.5 × 20.5 cm)

MATERIALS + TOOLS

- Basic encaustic tool kit (page 10)

- Cradled panel, 8" × 8" (20.5 × 20.5 cm), or 9 cradled panels each 3" × 3" (7.5 × 7.5 cm) for variation on page 137

- White acrylic paint or white encaustic gesso

- Multiple color copies on uncoated paper of a colorful painting or image

- Shredder or scissors

- Rives BFK or smooth watercolor paper, about 10" × 10" (25.5 × 25.5 cm) or enough to cover all panels

- X-Acto knife

- Metal ruler

- Cutting mat

- PVA glue or acrylic gel medium

- *Optional:* Metal measuring cup with lip for pouring wax

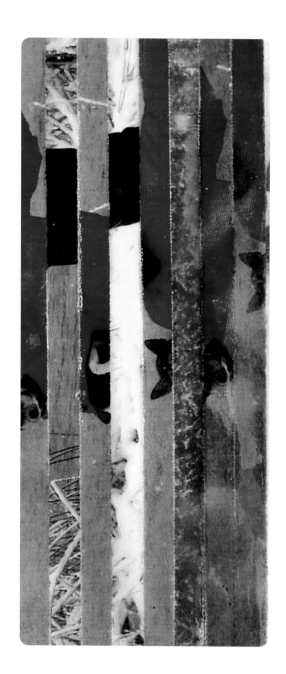

steps

1 | **Paint** the cradled panel or panels with white acrylic paint or white encaustic gesso. Let dry.

2 | **Shred or cut** into strips with scissors each of the color copies of your image. Shred each in the same way or vary the direction and widths of the cuts.

3 | With the ruler, cutting mat, and X-Acto knife, **cut** the Rives BFK or watercolor paper into a square slightly larger than the size of your panels.

4 | With PVA glue or gel medium, **glue** the strips from your color copies onto the square of paper, rearranging the strips so the image is distorted.

5 | **Glue** the composition onto the panel using PVA glue or acrylic gel medium. **Cover** with waxed paper and weight overnight with books or other weights.

6 | With the X-Acto knife and cutting mat, **trim** the excess paper around the sides of the panel or panels.

7 | **Melt** encaustic medium and **brush** onto each of the panels or heat up the panels and pour medium onto the surface. If you brush medium onto the panels, follow by fusing. If you pour medium onto the surface, no fusing is necessary.

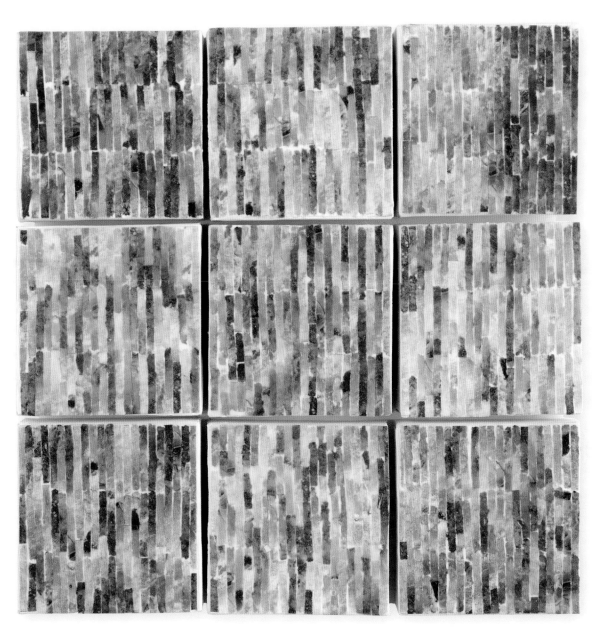

■ *Variation made
with nine small square
cradled panels.*

shredded
love letters

One day in the studio, I shredded a stack of thank-you notes, birthday cards, and love letters I had accumulated. These became art supplies for me, full of feelings of love and delicious creativity. When people take the time to write, stamp, and mail something, it means a lot. I take that into my work and give it back into the world in a new form.

FINISHED SIZE
As shown, 16" × 16"
(40.5 × 40.5 cm)

MATERIALS + TOOLS
- Basic encaustic tool kit (page 10)
- Cradled panel or other substrate with a smooth encaustic surface
- Collection of cards and letters
- Cross-cut shredder or scissors
- Burnishing tool
- Waxed paper
- *Optional:* white glue, metal measuring cup with lip

steps

1 | **Gather** all of your cards and letters; reread them and enjoy the love you received. Then put them through a cross-cut shredder or cut them with scissors or an X-Acto knife into long strips.

2 | **Think** about how you'd like to arrange the strips on the panel; I like to work with the tone and color of the strips to create subtle shapes within the panel. **Re-cut** strips as needed

to make patterns, such as the center squares in my pieces.

3 | The substrate can be cool or warm (but not hot). Use a burnishing tool to **burnish** strips on the sized panel in your desired arrangement. Use a sheet of waxed paper over the strips so you can burnish with vigor.

4 | **Brush** medium over the burnished strips. **Fuse.** Alternatively, heat the panel and pour

tip For a variation on this method, glue the shredded elements with white glue directly on an unwaxed panel that has been sized with encaustic gesso. Follow with encaustic medium. Fuse.

medium over the surface using the metal measuring cup as described on page 117.

■ *Shredded Love*
Letters II

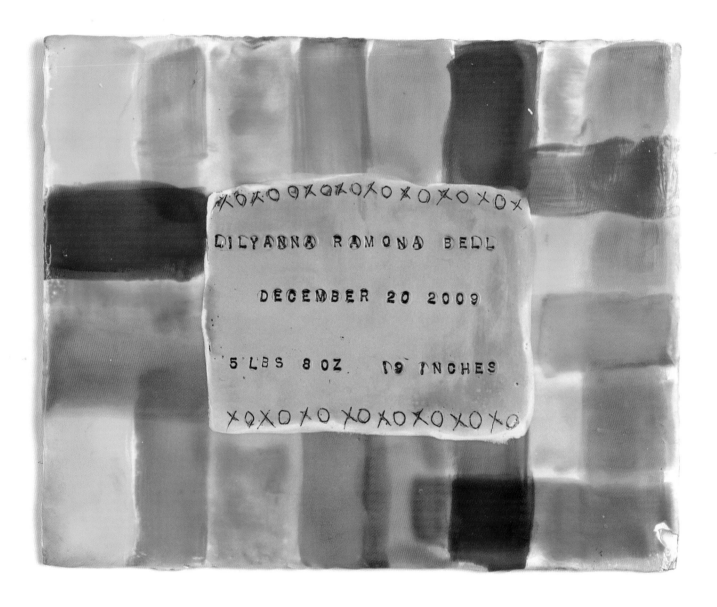

birth
celebration!

I took the idea of traditional cross-stitch embroideries with a child's birth data and transformed it into contemporary encaustic art to celebrate a child's birth. I make these pieces for all my friends and family members whenever a new baby enters the world. You can easily do the same.

FINISHED SIZE
As shown, 8" × 10"
(20.5 × 25.5 cm)

MATERIALS + TOOLS

- Basic encaustic tool kit (page10)

- Cradled panel or other substrate with smooth encaustic surface

- Vegetable oil or SoySolv II

- *Optional:* Pigment sticks or oil paints

- Razor blades or pottery tool such as Kemper LT-5 wire-end scraper

steps

1 | **Plan** your design, ensuring that you have room for all of the lettering.

2 | On a sized cradled panel, **paint** ten layers of encaustic paint in the color of your choice. Remember to fuse after each layer.

3 | **Press** metal stamps firmly into the wax surface to spell out the child's name and birth date. Use a release agent such as linseed oil or SoySolv II on your stamps so that they do not pull up the wax. Complete all text.

4 | **Fill in** the text with a contrasting color of paint, and scrape back the excess so that the text is beneath the surface. **Fuse.**

5 | Alternatively, put on vinyl or nitrile gloves and **fill** the text with a contrasting color of pigment stick, then **wipe** the surface clean with a rag or soft paper towel. If there is any pigment stick remaining on the surface, put a little linseed oil in a rag or paper towel and wipe clean. It is not necessary to fuse after submerging pigment stick beneath the surface.

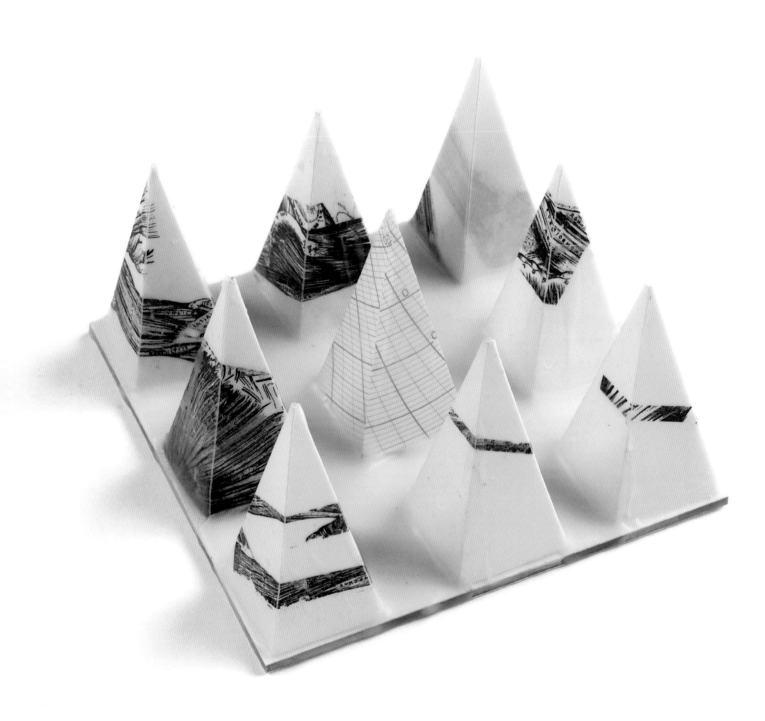

pyramids

I'm often inspired by tea bags, but in this case, it was the fabulous pyramidal packaging of Tea Forté that inspired me. I created a template from their packaging and share it with you with their generous permission. I cut pyramids out of Rives BFK, a beautiful paper designed for printmaking, dipped them into encaustic medium and transferred anatomical imagery, then formed the pyramids and assembled them on a substrate.

FINISHED SIZE
Each pyramid is 1½" (3.8 cm) at base and 3" (7.5 cm) tall. Assemblage as shown: 6" × 6" × 3" (15 × 15 × 7.5 cm).

MATERIALS + TOOLS
- Template (page 147)
- Rives BFK paper for pyramids
- Toner-based copies of transfer imagery

- Container for encaustic medium large enough for dipping pyramids
- Document repair tape
- 6" × 6" (15 × 15 cm) plywood panel
- Burnishing tool
- Scissors
- Bone folder

145

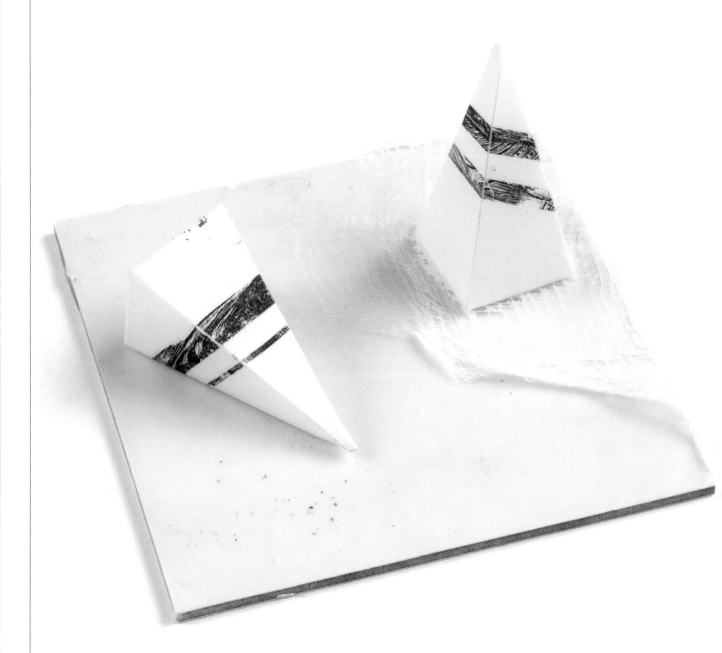

steps

1 | **Trace** the template on opposite page onto Rives BFK paper as many times as desired. Transfer fold markings. Cut the shapes out with scissors or an X-Acto knife on a cutting mat.

2 | **Dip** the shapes in medium, or **paint** medium directly onto your warm palette to melt it and brush it onto the paper shapes. Let dry.

3 | With a bone folder, **score** along the marked lines.

4 | While still flat, **transfer** imagery onto the paper shapes as desired (see various transfer techniques on pages 52 through 71).

5 | **Fold** and **seal** each form with document repair tape.

6 | Use the folded forms as multiple elements fastened to a panel with encaustic medium, or use in mixed-media assemblages.

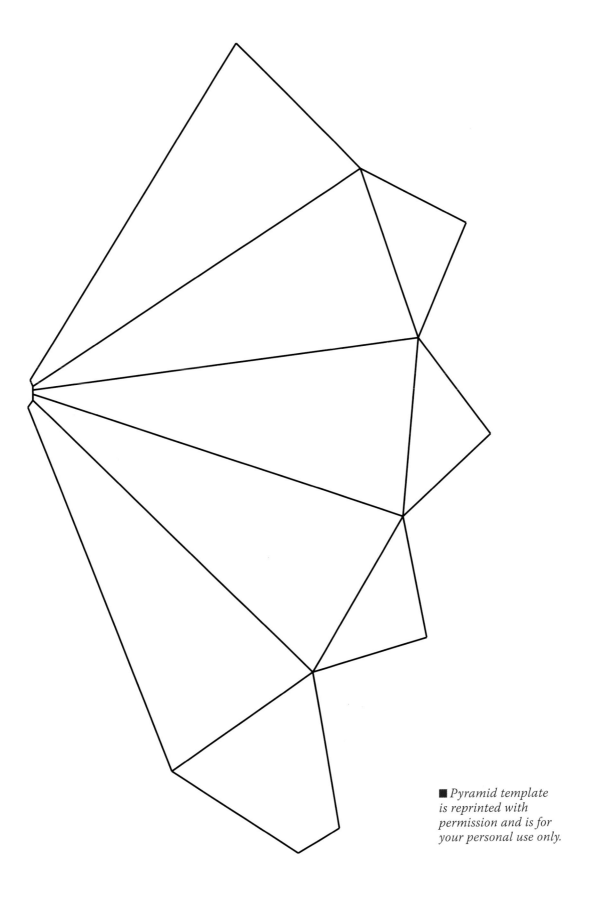

■ *Pyramid template is reprinted with permission and is for your personal use only.*

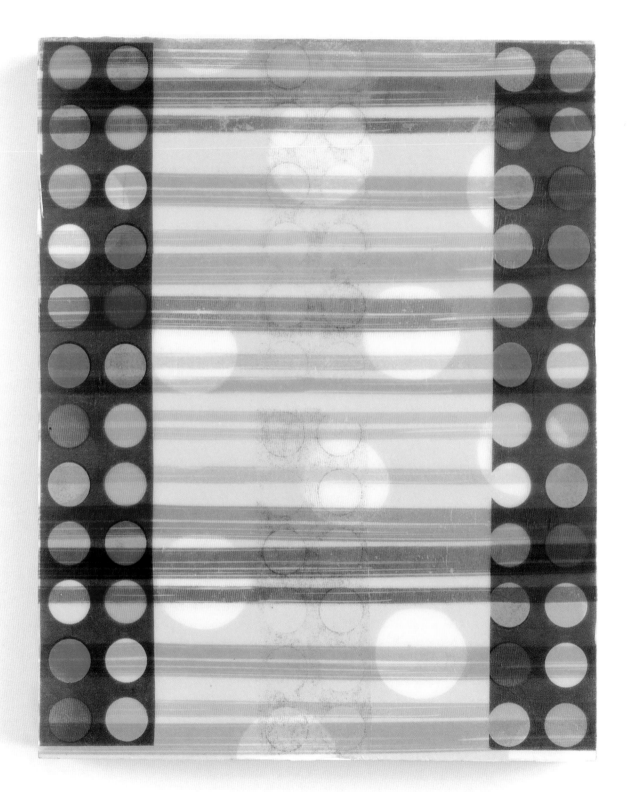

layers
of color

This is an easy project using colorful printed napkins; you can find these at any store that sells party supplies. These napkins typically have three layers; you'll peel away two of the layers to leave the tissue-thin printed top layer. In a collage, these sheer papers are enhanced by the translucency of the encaustic medium—build up lots of layers for a beautiful effect.

FINISHED SIZE
As shown, 8" × 10"
(20.5 × 25.5 cm)

MATERIALS + TOOLS
- Basic encaustic tool kit (page 10)
- Cradled panel or substrate with smooth sized surface
- Printed decorative paper napkins in varied colors and patterns
- Hot wax stylus pen with iron attachment

steps

1 | **Remove** the bottom two layers of napkins using painter's tape (see page 91, fig. 1). Discard the bottom layers. Cut or tear pieces of the colorful top layers of the napkins.

2 | **Place** a piece of napkin on your sized cradled panel or substrate. **Iron** the napkin with the hot wax stylus pen using the iron attachment. The wax from the sized surface will melt and encapsulate the napkin layer.

3 | **Continue** to add pieces of the printed napkins, creating a sort of layered archaeology. Many layers of medium will obscure or partially obscure the images. You may also paint medium over the surface, in addition to using the iron. Fuse after painting medium on the surface.

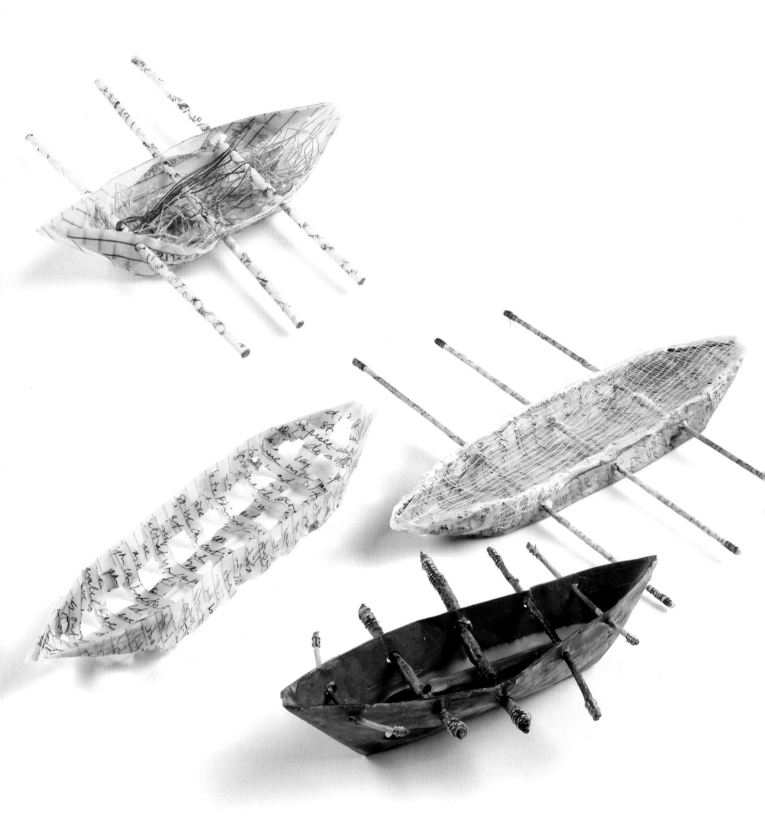

sail away boats

I learned to make these origami boats from Jennifer Ewing, an artist whose work I saw in an exhibition called Spirit Boat Directions at the DeYoung Museum in San Francisco, California. Viewers were invited to come in and construct boats, totems, and drawings from recycled materials. I've translated her idea to a three-dimensional encaustic project with infinite possibilities. The simple origami instructions are for a sampan, or flat-bottomed Chinese boat.

FINISHED SIZE

Variable, depending on paper size; an 8½" × 8½" (21.5 × 21.5 cm) square paper will yield a folded boat about 8¼" (21 cm) long by 1¾" (4.5 cm) wide, with sides 1¼" (3.2 cm) deep.

MATERIALS + TOOLS

- Basic encaustic tool kit (page 10)
- Sheets of paper such as recycled paper or architect's drawing tissue, cut to a square size
- Mixed-media supplies such as coffee and tea grounds, pens, paper, yarn, string, found objects
- 3 wooden dowels for oars, about ¼" (6 mm) in diameter
- *Optional:* Paint or other decorative treatment for oars
- Tape
- White glue

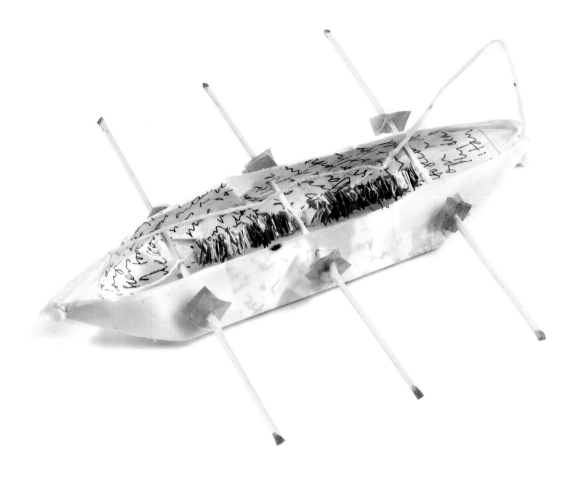

steps

1 | Follow the folding instructions at right to fold paper into a boat form.

2 | Add collage, string, embellishments, or other decorative elements to the boat. I used string to wrap the sides of some of my boats, tying knots along the sides.

3 | Paint melted encaustic medium on the sides and interior of the boat. If you wish, **pour** a layer of encaustic medium into the boat and embed things in the wax.

4 | Fuse gently with a torch or heat gun. Be careful not to burn the paper. Any paper that does not have wax on it will burn, so keep a wet cloth or paper towel at the ready; if anything catches fire, quickly use the wet cloth to put it out.

5 | Paint or **decorate** the dowels for the oars as desired. Roll the blade of an X-Acto knife over a dowel to cut it to the correct size, then score an "X" in the paper sides of the boat with the knife.

Push the dowel through the paper. Repeat with additional dowels. Paint a little molten wax inside the boat on the oars to secure them.

6 | Make a series of these in various shapes and sizes to hang on the wall, or create an installation using monofilament to hang the boats.

fold an origami sampan boat

a Fold sheet in half lengthwise.

b Open to full page and make two lengthwise folds to center.

c Fold corners to center in four equilateral triangles.

d Fold each corner again to center fold, over the previous triangles.

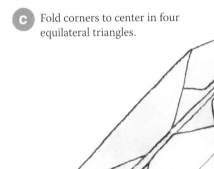

e Fold both sides to the center.

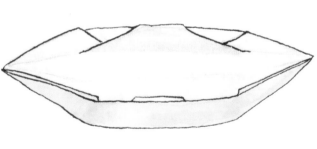

f Grasp the widest part of the shape on each side. Reach into the middle and gently turn the boat inside out. This is the hardest part!

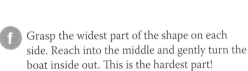

project

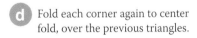

sail away boats

153

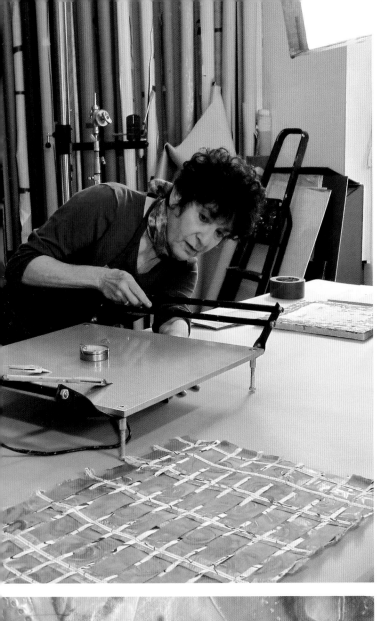

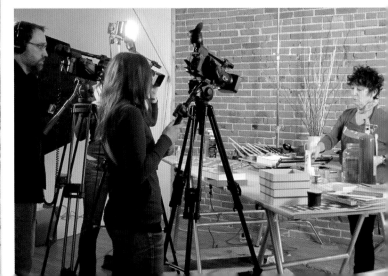

next steps *on the journey*

Now that you have some of my favorite techniques, along with instructions for some easy projects, you can take what you've learned in many directions. As I mentioned at the start of this book, encaustic can be the glue that brings all of your mixed media together. You now have a new set of tools—in fact, an entire new toolbox—with which to make art, and from it you can mix and match techniques to your heart's content.

There are only a few hard and fast rules to review: your substrates must be both rigid and porous; in most cases, you should fuse each layer to the one below; and you should avoid shiny papers, acrylic paint, and plastic stuff. You can always break the rules (we know you want to—you're an artist!), but the methods I teach in this book work and are archival.

As you explore encaustic, I strongly recommend that you work on more than one piece simultaneously so that nothing becomes too precious and you won't fear making a "mistake." New directions and ideas come from playing and experiencing happy accidents. Making art in a naïve, beginner's state of mind is a fertile wellspring for creativity. If you are overwhelmed by the enormity of your choices, remember to create a container by limiting your options—select just a few elements, ideas, colors, tools, or processes to work with.

Most importantly, make time to be alone in your studio without interruptions. Watch the DVD included with this book, be inspired, keep journaling, take classes, and experiment freely. Enjoy every step on this wonderful journey!

Daniella Woolf

■ *We had a wonderful day filming the enclosed DVD for this book, including the bonus Library Cards Mobile project (top right photograph). At top left, I'm setting up my palette for a day of waxy goodness.*

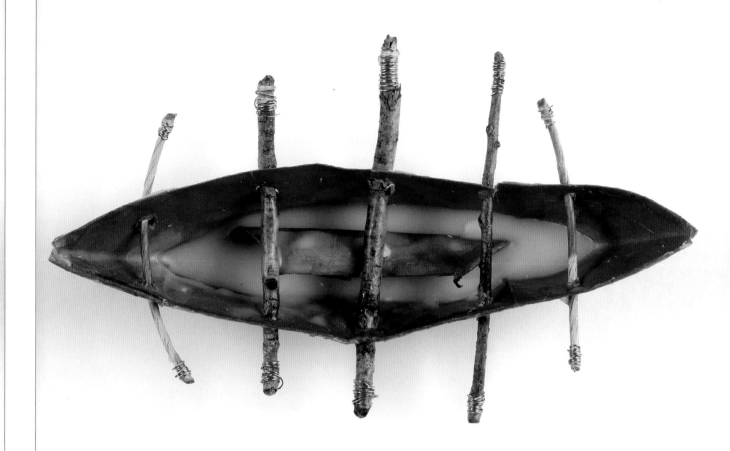

resources

Wax Works West
waxworkswest.com
(831) 786-9120

Encaustic classes taught by Daniella Woolf, Wendy Aikin, and Judy Stabile; a full range of encaustic tools and supplies including palettes, heat guns, torches, hot wax stylus pens, Iwatani torches, encaustic irons, heat-resistant gloves, split-shank hake brushes, imported papers, Daniella Woolf DVDs, and more.

Encaustic Materials + Tools

Ampersand
ampersandart.com
(800) 822-1939
Encausticbord and other painting panels for artists.

Clairvoyant Encaustic
clairvoyantencaustics.com
(831) 239-1985

Handmade encaustic medium.

Daniel Smith
danielsmith.com
(800) 426-6740

SoySolv II soy-based solvent, encaustic supplies, and other art supplies.

Enkaustikos
encausticpaints.com
(585) 263-6930

Professional encaustic paints including Hot Cakes and Hot Sticks, encaustic medium, and more.

Evans Encaustics
evansencaustics.com
(707) 996-5840

Classes, encaustic paints and medium, encaustic gesso in white and colors, hake brushes, and more.

Miles Conrad Encaustics
custom-encaustics.com
(520) 622-8997

Classes, handmade encaustic paint, encaustic travel workshops, and supplies including Solve It soy-based solvent.

Northwest Encaustic
nwencaustic.com

Classes, studio rental, and encaustic paints and medium.

R&F Handmade Paints
rfpaints.com
(800) 206-8088

A full range of encaustic supplies, including paints, medium, tools, palettes, Pigment Sticks, Encausticbord panels, Invisible Glove barrier cream, safety and ventilation guidelines, an online forum, workshop and exhibition program, and technical papers on encaustic-related subjects.

Rodney Thompson Fine Art
rodneythompson.com
Specialty cradled panels for encaustic, holders/holsters for torches and heat guns.

Roland Workshops
rolandworkshops.com
Encaustic classes and the Roland HOTbox.

Additional Resources

Costco
costco.com

Nitrile gloves.

Dadant and Sons
dadant.com
(877) 332-3268

Beeswax and beekeeping supplies.

Designs Ink
designsinkart.com

Float frame kits.

Eco Green Crafts
ecogreencrafts.com

Chipboard.

Educational Innovations
teachersource.com
(888) 912-7474

Neodymium magnets for hanging artwork.

Interweave Store
interweavestore.com

Mixed-media art supplies, books, and magazines.

Hiromi Paper International
hiromipaper.com
(866) 479-2744

Specialty papers for encaustic, monoprinting, and collage.

Jacquard Products/Rupert, Gibbon & Spider
jacquardproducts.com
(800) 442-0455

Encaustic medium, ExtravOrganza, textile paints and dyes, and tools.

Kemper Tools
kempertools.com
(800) 388-5367

Pottery tools and other art tools.

Lenz Arts
lenzarts.com
(831) 423-1935
Rives BFK paper.

Ranger Ink
rangerink.com

Perfect Pearls Mists, Mold-n-Pour mold compound.

Seven Gypsies
sevengypsies.com

Chipboard, stamps, and collage and mixed-media materials.

The Cary Company
thecarycompany.com
(630) 629-6600

Paint cans.

Utrecht Art Supply
utrechtart.com
(800) 223-9132

Split-shank hake brushes, art supplies.

Associations + More

Daniella Woolf
encausticopolis.blogspot
.com (blog)
daniellawoolf.com
(website)

International Association of Hand Papermakers and Paper Artists (IAPMA)
iapma.info

International Encaustic Artists (IEA)
international-encaustic
-artists.org

Surface Design Association
surfacedesign.org

Australian Suppliers

Parkers Sydney Fine Art Supplies
parkersartsupplies.com

Encaustic paints and medium, oil sticks, and more.

Chapman & Bailey
chapmanbailey.com.au

Encaustic paints and medium, oil sticks, and more.

bibliography

In 2008, I won a fellowship that allowed me to improve my library. When I go to a museum exhibition, I buy the catalog, at the very least, and I regularly make many other book purchases. Not all of these books are directly related to encaustic painting or even to art, but all have influenced my aesthetic and practice.

Bayles, David, and Ted Orland. *Art and Fear.* Santa Barbara, California: Image Continuum Press, 2001.

Bender, Sue. *Plain and Simple: A Woman's Journey to the Amish.* New York: HarperOne, 1991.

Box, Richard. *Drawing for the Terrified! A Complete Course for Beginners.* Devon, United Kingdom: David & Charles, 1999.

Brownell, Blaine, ed. *Transmaterial 2: A Catalog of Materials that Redefine Our Physical Environment.* Princeton, New Jersey. Princeton Architectural Press, 2008.

Cameron, Julia. *The Artist's Way,* New York: Penguin, 2002 (10th Edition).

Carriker, Pam. *Art at the Speed of Life.* Loveland, Colorado: Interweave, 2011.

Chippindale, Christopher. *Stonehenge Complete,* 3rd Edition. London: Thames & Hudson, 2004.

Doczi, Gyorgy. *The Power of Limits: Proportional Harmonies in Nature, Art and Architecture.* Boston: Shambhala Publications, 2005.

Drucker, Johanna. *Figuring the Word: Essays on Books, Writing and Visual Poetics.* New York: Granary Books, 1998.

Dunnewold, Jane. Art Cloth: *A Guide to Surface Design for Fabric.* Loveland, Colorado: Interweave, 2010.

Eames, Charles and Ray. *Powers of Ten: A Flipbook.* New York: W.H. Freeman and Co., 1998.

Gladwell, Malcolm. *Blink: The Power of Thinking Without Thinking.* New York: Little, Brown & Co., 2005.

Gladwell, Malcolm. *Outliers: The Story of Success.* New York: Little, Brown & Co., 2008.

Goldberg, Natalie. *Writing down the Bones: Freeing the Writer Within.* Boston: Shambhala Publications, 1986.

Hedley, Gwen. *Drawn to Stitch: Line, Drawing, and Mark-making in Textile Art.* Loveland, Colorado: Interweave, 2010.

Holmes, Cas. *The Found Object in Textile Art.* Loveland, Colorado: Interweave, 2010.

Innes, Jocasta. *The New Paint Magic.* New York: Pantheon, 1992.

Jones, Heather Smith. *Water Paper Paint.* Minneapolis: Quarry Books, 2011.

Jones, Owen. *The Grammar of Ornament.* New York: Gramercy Press, 1988 (first published London, 1856).

Lamott, Anne. *Bird by Bird: Some Instructions on Writing and Life.* New York: Anchor, 1995.

Lang, Cay. *Taking the Leap: Building a Career as a Visual Artist (The Insider's Guide to Exhibiting and Selling Your Art).* San Francisco: Chronicle Books, 2006.

Mattera, Joanne. *The Art of Encaustic Painting.* New York: Watson-Guptill, 2001.

Pastoreau, Michael. *The Devil's Cloth: A History of Stripes.* New York: Washington Square Press, 2003.

Pratt, Frances, and Becca Fizell. *Encaustic, Materials and Methods.* New York: Lear Publishers, 1949 (out of print).

Pressfield, Steven. *The War of Art.* New York: Warner Books, 2003.

Rankin, Lissa. *Encaustic Art: The Complete Guide to Creating Fine Art with Wax.* New York: Watson-Guptill, 2010.

Rivers, Victoria Z. *The Shining Cloth: Dress and Adornment that Glitters.* London: Thames & Hudson, 1999.

Rudofsky, Bernard. *Architecture without Architects.* Albuquerque, New Mexico: University of New Mexico Press, 1987.

Schmidt, Christine. *Print Workshop: Hand-Printing Techniques and Truly Original Projects.* New York: Potter Craft, 2010.

Stavitsky, Gail, Daniella Rice, et al. *Waxing Poetic: Encaustic Art in America.* Piscataway, New Jersey: Rutgers University Press, 2000.

Thomas, Peter, and Donna Thomas. *More Making Books By Hand: Exploring Miniature Books, Alternative Structures, and Found Objects.* Minneapolis: Quarry Books, 2004.

Wallace, Eileen. *Masters: Book Arts: Major Works by Leading Artists.* Asheville, North Carolina: Lark Crafts, 2011.

Womack, Linda. *Embracing Encaustic: Learning to Paint with Beeswax.* Magalia, California: Hive Publishing, 2008.

index

Explore more mixed-media inspiration and techniques
with these innovative resources from Interweave

Art at the Speed of Life
Motivation + Inspiration for Making
Mixed-Media Art Every Day

Pam Carriker

ISBN 978-1-59668-261-0
$22.95

**The Cloth Paper
Scissors Book**
Techniques and Inspiration for
Creating Mixed-Media Art

Barbara Delaney

ISBN 978-1-59668-397-6
$24.95

**Inside the
Creative Studio**
Inspiration and Ideas for Your
Art and Craft Space

Cate Coulacos Prato

ISBN 978-1-59668-398-3
$24.95